Donald Rodney
Autoicon

Richard Birkett

First published in 2023
by Afterall Books

One Work Series Editors
Elisa Adami
Mark Lewis

Managing Editor
Elisa Adami

Assistant Editor
Wing Chan

Copy Editor
Deirdre O'Dwyer

Design
Andrew Brash

Typefaces for interior
A2/SW/HK ≠ A2-Type

Printed and bound by
die Keure, Belgium

The *One Work* series is printed
on FSC-certified papers

ISBN 978-1-84638-257-4

Distributed by
The MIT Press,
Cambridge, Massachusetts and London
www.mitpress.mit.edu

Afterall
Central Saint Martins
Granary Building
1 Granary Square
London N1C 4AA
www.afterall.org

Afterall is a Research Centre of University of
the Arts London and was founded in 1998 by
Charles Esche and Mark Lewis.

Director
Mark Lewis

Associate Directors
Chloe Ting
Adeena Mey

Project Coordinator
Camille Crichlow

Supported using public funding by
ARTS COUNCIL
ENGLAND

ual: central
saint martins

Each book in the *One Work* series presents a single work of art considered in detail by a single author. The focus of the series is on contemporary art and its aim is to provoke debate about significant moments in art's recent development.

Over the course of more than one hundred books, important works will be presented in a meticulous and generous manner by writers who believe passionately in the originality and significance of the works about which they have chosen to write. Each book contains a comprehensive and detailed formal description of the work, followed by a critical mapping of the aesthetic and cultural context in which it was made and that it has gone on to shape. The changing presentation and reception of the work throughout its existence is also discussed, and each writer stakes a claim on the influence 'their' work has on the making and understanding of other works of art.

The books insist that a single contemporary work of art (in all of its different manifestations), through a unique and radical aesthetic articulation or invention, can affect our understanding of art in general. More than that, these books suggest that a single work of art can literally transform, however modestly, the way we look at and understand the world. In this sense the *One Work* series, while by no means exhaustive, will eventually become a veritable library of works of art that have made a difference.

Donald Rodney
Autoicon

Richard Birkett

I am very grateful to Amber Husain and David Morris at Afterall for their support and enthusiasm for this project at its early stages, and to Elisa Adami for her insightful editorial work and patience over the course of its writing.

This book is particularly indebted to Diane Symons and her deep generosity in sharing thoughts, memories, ideas, references and images around Donald Rodney and his work. Diane's care for Rodney's material, conceptual and affective legacy has been an inspiration. Similarly, I am hugely thankful for the time, insight and support offered in the development of this text by Mike Phillips, Virginia Nimarkoh, Gary Stewart and Ian Sergeant; and to Keith Piper, Eddie Chambers and Richard Hylton for their long-term commitment to the presentation of, and discursive engagement with, Rodney's practice. I would also like to acknowledge, with great appreciation, the writing and thinking of Celeste-Marie Bernier, Jareh Das and Stephen Weller, whose recent research into Rodney's work has generated invaluable knowledge and discourse; and to those who provided vital reflection, context and support for the work during Rodney's lifetime, including John Akomfrah, Sonia Boyce, Eddie George, Lubaina Himid, Trevor Mathison, Maud Sulter and David Thorp. I learnt a great deal through the Donald Rodney Papers held at Tate Library and Archives, and the archives and publications at the Stuart Hall Library, Iniva – I am particularly grateful to Sepake Angiama and Tavian Hunter at Iniva for their assistance. I would also like to thank Graham Harwood, Shu Lea Cheang, Keith Piper and Roshini Kempadoo for supporting the inclusion of their work in this volume; and Carolyn Lazard and Park McArthur for their engagement and the formative nature of their practices.

For their reading, ideas, reflections and friendship I am eternally grateful to Em Hedditch, Alhena Katsoff, Charlotte Linton and Cameron Rowland. The research towards this volume would also not have been possible without the funding support of The Paul Mellon Centre for Studies in British Art.

Richard Birkett is a curator, writer and director of Glasgow International. He was chief curator at the Institute of Contemporary Arts, London, from 2017 to 2020, and previously curator at Artists Space in New York. He has worked with artists, writers, and film-makers including Terry Atkinson, Julie Becker, Bernadette Corporation, Chto Delat, Forensic

Architecture, Em Hedditch, Chris Kraus, Taylor Le Melle, Laura Poitras, Cameron Rowland and Hito Steyerl. He has recently written on the work of Dora Budor, Andrea Büttner, Maria Eichhorn, Carolyn Lazard and Adrian Paci, and co-edited publications including *Cosey Complex* (2012), *Bernadette Corporation: 2000 Wasted Years* (2013) and *Tell It To My Heart – Collected by Julie Ault, Volume 2* (2015).

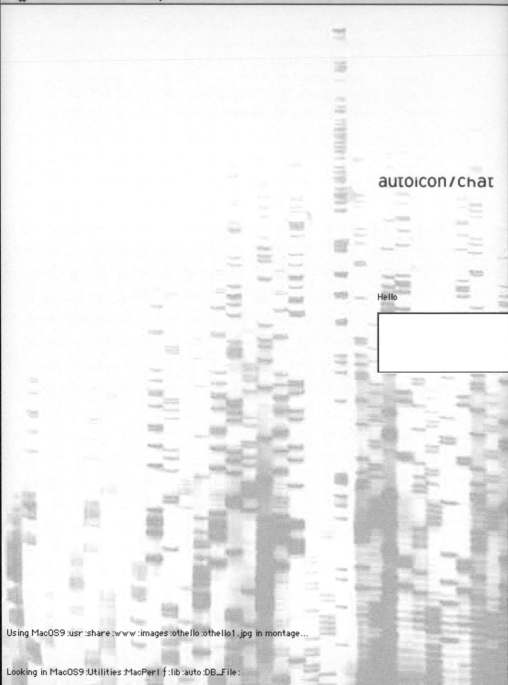

File Activities Help

autoicon/chat

Hello

Using MacOS9 :usr :share :www :images :othello :othello1 .jpg in montage...

Looking in MacOS9 :Utilities :MacPerl ƒ :lib :auto :DB_File :

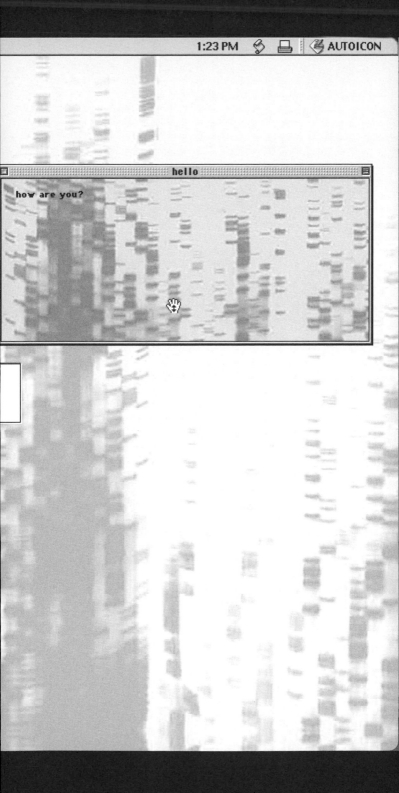

Contents

Preface

Human as a hybrid-auto-instituting-languaging-storytelling species.
- Sylvia Wynter[1]

Whether an encounter with Donald Rodney's *Autoicon* occurs today or took place in the years immediately following its launch in 2000, a short introductory text likely prefigures the interaction. Posted on the website of the London-based Institute of International Visual Arts (Iniva), which hosted *Autoicon*'s original Web iteration, or printed as the sleeve notes accompanying the work's CD-ROM version, the text begins: 'AUTOICON is a dynamic artwork that simulates both the physical presence and elements of the creative personality of the artist Donald Rodney who – after initiating the project – died from sickle-cell anaemia in March 1998.'[2] Further priming the reader as to the interactive nature of the work, the text goes on to state: 'Users will encounter a "live" presence through a "body" of data (which refers to the mass of medical data produced on the human body), be able to engage in simulated dialogue (derived from interviews and memories), and in turn affect an auto-generative montage machine that assembles images collected from the web [or in the CD-ROM version, 'from the user's hard-drive'] (rather like a sketchbook of ideas in flux).' The prescribed interactivity of *Autoicon* – to 'encounter', 'engage' and 'affect' – establishes an imminent, existential relation between the user and a distinctive interlocutor: an approximation of the artist Donald Rodney that is also a 'live' presence, an extension of personhood beyond death.

Today, however, *Autoicon* is largely inaccessible due to its reliance on obsolete hardware and software. As a Web platform, the work's life span lasted around sixteen years, ending with an upgrade of the Iniva website in 2017. The *Autoicon* CD-ROM was published several months after the website's launch, as a result of anxieties about the accessibility of the Web version to a general audience. As I am writing this, in 2021, *Autoicon* has recently been presented in an exhibition in Glasgow, where I live.[3] Following the exhibition's closure, the work was loaned to me in the form of an Apple eMac desktop computer from circa 2002, which runs an *Autoicon* CD-ROM through an emulation of the Mac OS 9 operating system originally launched in 1999. To my knowledge, no written or video documentation of an inter-

action with the Web version between 2000 and 2017 exists – I am reliant here on my own memories of accessing *Autoicon* online, alongside those of others.[4] Experienced online, the work functioned with additional capacities beyond its CD-ROM version, constantly pulling material from the Web – a technology that itself constitutes a perpetually changing and expanding archive – and learning from its interactions with a dispersed network of potentially simultaneous users. In their inception, the Web and CD-ROM versions constituted a bifurcation of parameters for growth and change, which became a multiplication in subsequent interactions with the work, where each user necessarily experienced and influenced a distinct iteration of *Autoicon*.

Aware that this state of partial access and temporal contingency is a constitutive dimension of *Autoicon*'s realisation in, rather than merely by, technology, my intent here is not to interpretively fix the artwork 'in absentia' but to think with *Autoicon* as an absent presence, an abiding extension of Rodney's polyvalent thought. This book is divided into four chapters: 'The hardware', 'The software', 'The surroundings', and 'The interaction'. These terms are gratefully lifted from a protocol for the documentation of net art, devised in 2011 by artist Constant Dullaart and curator Robert Sakrowski. Understanding net art[5] as 'a work that is meant to be shown on a personal computer, making use of its connection to the World Wide Web',[6] Dullaart and Sakrowski grappled with the conspicuous problems in documenting such works given that the 'context, the private atmosphere, and the hardware interaction defines a large part of the "net art activity"'.[7] Documentation, as outlined by Dullart and Sakrowski, should represent four layers:

> 1. *The hardware: computer, monitor, keyboard, mouse, net access, handheld devices, laptops etc.*
> 2. *The software: operating system, browser, server, plug-ins and Flash, Java etc.*
> 3. *The surroundings: noise, furnishing, living room, working space, bedroom, other people in the room.*
> 4. *The interaction: collaboration, participation of the recipient.*[8]

My use of these categories as chapter headings is not, however, an attempt to apply this protocol in descriptive form to the heterotopia that is *Autoicon*. Rather, in hardware, software, surroundings and interactions, this book lo-

cates a guiding framework for the objects, events, people, ideas, behaviours and properties that constitute *Autoicon*. They are terms to be read in excess, in that to address *Autoicon* requires a necessarily capacious engagement with the 'presence' of Donald Rodney and his work. In 'hardware' we might recognise a momentary fixity of terms, a set of conditions and artefacts that form a basis for what is to come; in 'software', a directing force that is linguistic, idiomatic and ideological; in 'surroundings', an environmental character that is material and historical, social and genealogical, private and public; and in 'interactions', the affectability between or within physical bodies and their contexts.

The hardware

User: Hello

Autoicon *[text]: how are you?*

User: I'm ok. How are you?

Autoicon *[sound file, recording of Donald Rodney]: '... pain, is there constantly ...'*

User: Where do you feel pain?

Autoicon *[sound file, recording of Donald Rodney]: '... it's slow necrosis of the joints, and the necrosis means that the joints are slowing breaking down, slowly corroding ...'*

User: How did your illness impact on your work as an artist?

Autoicon *[sound file, recording of Donald Rodney]: '... simply calling our work propaganda, I think people should go and look at art that has been produced by so-called Western artists. Each piece of work has been set up to propagate their own lifestyles or their money, their wealth ...'*

User: Was your art seen as too political by some people?

Autoicon *[text]: I was actually thinking that yes, this is a career. And by that time I knew of other Black artists. Not that many, but I knew of Rasheed and I knew of Eddie, and the Black Audio Film Collective. Because we'd had the conference in Wolverhampton – the first National Black Art Conference – just think of the sheer arrogance of students organising the first conference on Black arts – the sheer arrogance of it (self-mocking/laughing). It was attended by the Black Audio Film Collective, and Sonia Boyce who I'd never met before and people who would then go on to open the Black Art Gallery.*

User: Did dialogue with other black artists change your work?

Autoicon *[video, image heavily blurred, slow zoom towards the head and shoulders of Rodney set against a pale-yellow background]: '... just to put on exhibitions, and to discuss amongst ourselves what type of, um, issues we raise in our work. But we don't operate as a group, um, to tell each other what type of work to produce, we're collective, we're, we're free ...'*

User: What does freedom mean to you?

Autoicon *[sound file, recording of Donald Rodney]: 'Like, I'm trying to be an artist.'*

User: Is Autoicon *an artist?*

Autoicon *[text]: MESSAGE STARTS ...*

DAVE VISITS DONALD IN HOSPITAL. STOP. DONALD TELLS DAVE PLAN TO MAKE FILM WITH CINE-CAMERA. STOP. DAVE SEES 8MM SEGMENT IN BLACK-AUDIO FILM COLLECTIVE DOCUMENTARY. STOP. LIGHT, ANGLE, MUTED COLOUR, HUMAN SHAPES, RESONANCE, FEEL. STOP. DAVE SAYS 'NOW THAT BOY'S AN ARTIST!' STOP. DAVE LEWIS. MESSAGE ENDS

User: *This makes me think of your use of X-rays in your work ...*

Autoicon *[image, X-ray of human hand]*

User: *Did you feel reduced to medical data as you spent longer periods in hospital?*

Autoicon *[video, reddish-pink abstract image with darker lines suggesting view through microscope of blood cells]*

User: Autoicon *references Jeremy Bentham. What do you think of his ideas?*

Autoicon *[image, blurred Auto-Icon of Jeremy Bentham with overlaid text]:* 'How little service so ever it may have been in my power to render to mankind during my lifetime, I shall at least be not altogether useless after my death.' – Jeremy Bentham

User: *He seemed interested in his legacy, his intellectual property, after death ...*

Autoicon *[text]: That is a hair and we don't know whose hair it is. I don't know if it's mine or hers. It's intriguing isn't it?*

– Conversation between the author and *Autoicon,* July 2021[9]

Launching the *Autoicon* CD-ROM lands the user in an ascetic digital platform-space. A predominantly greyish-white screen bears a full-bleed backdrop of faint-grey vertical stacks, the familiar representation of a DNA test (fig.2). The visual product of chromosomes stained and viewed under a microscope, then organised into graph-like tabulation, the sequence of light and dark bands portrays and indexes parts of a person's genetic code – in this case, that of Donald Rodney (fig.1). Over this background, a loading script populates the lower left-hand corner of the screen, with *Autoicon*'s menu bar running across the top edge, offering minimal options: 'File', 'Activities' and 'Help'. In the centre of the screen a stylised font states 'autoicon/chat' above an empty white rectangle, appearing like a window through the chromosomal stacks. A blinking text cursor within the window provides a call to action.

The simplicity of *Autoicon*'s landing page summons a computational lineage that began in the 1960s with automated chatbots – natural language processing programmes such as ELIZA – and online chat rooms, which first took public form with the real-time, letter-by-letter text communication of Talkomatic (created in 1973 and beloved of online communities in the 1980s).[10] By the mid-1990s, this lineage had reached the zenith of The Palace, which enabled users to create their own graphical chat room complete with animated avatars.[11] *Autoicon*'s invitation to chat favours the visual austerity of Talkomatic, offering no visual representation of conversation participants, or for that matter, little textual or visual pointers. In this instance, like ELIZA, the avatar is the programme itself – a construct of computational code established to mirror the supracorporeal 'code' of Donald Rodney – rather than that of another online user. Today, access to *Autoicon* provides an object lesson in the user interface as a primary trace of media history; at the same time in its austerity, the work succeeds in being relatively timeless. Like the cytogenetic map that forms its backdrop, it signals both a specific set of past conditions and instructions, and the projection of future manifestations.

When writing or talking about artworks, there are conventions and habits that often lead us to confer particular temporal status on them, based on their perceived material presence or absence. We might use the present tense for a work that still exists in the world, dispersing its effects in the active experience of it; or the past tense, for a work bound to a specific, now lost context, or destroyed by accident or design. Under this logic, Rodney's *Autoicon* is difficult to locate in either present or past tense. There is the lingering sense that the time of its action, its completeness or continuance, is not possible to bind to either tense without the other, nor, for that matter, without the future tense. Not only do the Web and CD-ROM versions exist in different states of (non)functionality, but present-day conversations about the work's 'conservation', its possible technical 'upgrade' for re-activation and re-circulation off and online, necessitate referring to what it *could* be.[12]

It is a key ontological condition of net art and the format of the interactive CD-ROM that they exist through multiple and unlimited interactions. *Autoicon* is no different. Yet in its 'simulation' of an afterlife, as much as in its enactment of a 'before', *Autoicon* requires an engagement not only with its past, present and future activations, but with the temporal anteriority of Rodney's biography. As the name suggests, *Autoicon* is a self-likeness. Its

conception therefore encompasses Rodney's artistic life and actions: from his body of work produced from the early 1980s on, to his methodologies, discursive relations and influences – notably, his formative involvement in collective organising and exchange with other black artists in Britain,[13] including as part of The Blk Art Group between 1982 and 1984[14] – his aesthetic and political concerns, and his personal and familial history – particularly, his parents' move from Jamaica to Birmingham in 1958, before Rodney's birth in 1961. It is necessary therefore to add a fourth temporality to the mix when addressing the work, one perhaps best captured by the past perfect continuous: the tense of *Autoicon* in its extended conception by Rodney, as opposed to, but relative to, its moment of completion. Early conversations between Rodney and his friend Mike Phillips that would eventually feed into *Autoicon* had taken place while both were studying at the Slade School of Fine Art between 1985 and 1987, inspired by the presence of nineteenth-century philosopher Jeremy Bentham's Auto-Icon in the main cloisters of University College London (fig.24). Returning to these conversations, Rodney further developed *Autoicon* during a period of frequent hospitalisations in the mid-1990s that nonetheless yielded many concepts for new works, a number of which were realised with the support of Phillips, Rodney's partner Diane Symons and other collaborators – a group that became an informal collective of care and facilitation. *Autoicon* had been a spectral, background presence in this period, an idea now inseparable from other lines of thought and possible projects, including a work utilising computer game technology to be developed with Gary Stewart, the head of multimedia at Iniva; a 'digital studio' conceived with artist Virginia Nimarkoh; and most significantly, the body of ideas and work eventually distilled into Rodney's extraordinary 1997 solo exhibition '9 Night in Eldorado' at South London Gallery.

When considering this extended context surrounding *Autoicon's* development and production, questions of tense – the time of its happening in relation to the time of its re-visitation – alongside those of authorship, start to take on a resonance beyond the grammatical and proprietorial terms of art history. They point instead to conceptions of life and its boundaries, as intimately woven by structural, corporeal and interpersonal conditions. In 1997, Rodney and Phillips completed an application to Arts Council England for funds to produce *Autoicon*. In March 1998, the day the award letter from the Arts Council was received, Rodney died from complications surround-

ing sickle cell anaemia, a disease he was diagnosed with as a child. *Autoicon* was completed two years later, overseen by Phillips and his colleagues Adrian Ward and Geoff Cox at Science Technology Arts Research (STAR) at the University of Plymouth, alongside a number of Rodney's past collaborators and interlocutors working under the ironic name Donald Rodney plc, including Symons, Stewart, Nimarkoh, Eddie Chambers, Richard Hylton and Keith Piper.

Autoicon is in fact predicated on Rodney's death. The death of the author was to be followed by a reanimation in the hands of a 'company' of friends and co-authors, echoing Michel Foucault's proclamation that in 'the author's disappearance ... we should attentively examine, along its gaps and fault lines, its new demarcations, and the reapportionment of this void; we should await the fluid functions released by this disappearance'.[15] The Arts Council application itself refers to an incident in 1988, when a review of a group exhibition in the magazine *20/20* inaccurately pronounced: 'Rodney, who suffered from a rare blood disease, did not live to see his work in this show'.[16] From this premature announcement of death, the application lays out a vision for *Autoicon*: for the assembly of a 'virtual body' fashioned from Rodney's biomedical 'data trail of information: photographs, X-ray's, scans, measurements, data, scars, and imprints'; the endowment of this 'avatar' with 'Rodney's memories and experiences, fleeting images of the past, captured in a dynamic digital album of live "media"'; and the 'inclusion of an artificial intelligence [to] allow visitors to enter into conversation and discuss the development of new ideas and projects, that can evolve and be maintained in the organic Rodney's absence'. The application details how, through this avatar, 'like Jeremy Bentham, whose embalmed body still sits in the corridor of University College London, ... Rodney will join the distinguished club of the un-dead'.[17]

Bentham aspired to the ongoing presence of both his material form and his personhood, imagining scenarios under which, following the rhetorical device of prosopopoeia, the very manifestation of his embalmed body would provoke and engage in discourse with worthy interlocutors of the past and future.[18] The form of Rodney's *Autoicon* is likewise predicated on accretion of dialogue and interaction with multiple 'users', while offering a contained and 'private' experience for each, the content of which is partly contingent on their actions. However, whereas Bentham's Auto-Icon was seemingly

conceived with the belief in a durable unity of identity post-death, *Autoicon* embraces a wilful opacity, an always partial and dispersed conveyance of identity. Any answer to the question 'Who, or what is speaking?' in *Autoicon* becomes manifold and entangled: The *Autoicon* programme? Donald Rodney? The programme architects, Donald Rodney plc? *Autoicon* simulating Donald Rodney based on the memories of the members of Donald Rodney plc? *Autoicon* users and the accumulated effect of their interactions? The question is further complicated by the work's conception as a networked platform, affected not just by its users but also by the entire evolving ecosystem of the Internet.[19]

This conception of *Autoicon* as part repository, part continuance of consciousness and creative production beyond death, marks the auto-institutional exigency of the work. Intrinsically bound to the physical, intellectual and social necessities of the final years of Rodney's life, when he was confined for longer periods to a hospital bed, *Autoicon* explores the implications, in Sylvia Wynter's words, of 'our having been, from our species origin, hybridly (skins/masks, phylogeny/ontogeny/sociogeny, *bios/mythoi*, and thereby always hitherto, *relatively*) human'.[20] At its core, *Autoicon* is composed around the remnants of Rodney's life, from his artworks, to traces of his body, to audio and video recordings of him speaking; and around the acts of collectivity, aggregation and care undertaken by Donald Rodney plc to realise the work. In engaging with *Autoicon*, the user is not simply an observer, a witness to the life/body that these remnants partially document, but is called to enter into its interstices, to engage in writing and re-writing a state of being that is simultaneously biological, cultural and affectable – or in Wynter's articulation, a 'hybridly organic' and '*languaging* existence'.[21]

Encounter, engage, affect

In 1973, Stuart Hall's paper 'Encoding and Decoding in the Television Discourse' introduced a model of media interactivity that emphasised the acts of decoding undertaken by every audience member, recipient or user of media:

> *The degrees of 'understanding' and 'misunderstanding' in the communicative exchange depend* both *on the degrees of symmetry/asymmetry between the position of encoder-producer and that of the*

decoder-receiver: and also *on the degrees of identity/non-identity between the codes which perfectly or imperfectly transmit, interrupt or systematically distort what has been transmitted.*[22]

Such a process of encoding and decoding is exemplified in the ebb and flow of an exchange with *Autoicon,* where the latter's particular coding results in an antiphony full of gaps and deviation. Typing into the chat box and hitting return prompts the text to be logged above (fig.3). Rather than a response appearing in the same box, the entry generates a pop-up window in a random location on the screen, titled with a single keyword related to the statement or question submitted. The response can take the form of a text, or an image, sound or video file; a segment of a transcription, of Donald Rodney speaking, or a recording; a medical X-ray, scan or microscopic image; a hypertext link to another website; or a seemingly random gif or jpeg of late-90s Internet iconography (fig.3–9). Incrementally, the programmatic pattern of pop-up titles and responses reveals an internal logic of trigger words, at times distinctive (for instance, 'Bentham') and at others less so (the adverb 'how' generates multiple different responses). The premise of talking with Rodney is largely delimited by the extant media archive of recorded or written interviews with the artist, including three vital audio-visual documents: Channel 4's *State of the Art: Ideas and Images of the 1980s* (1987); Valerie Thomas and Ceddo Workshop's *The Flame of the Soul* (1990); and Eddie George and Trevor Mathison of Black Audio Film Collective's *Three Songs of Pain, Time and Light* (1996, fig.25).[23] The clips from these videos that appear in the chat have often been cropped and layered with digital effects, in many cases to the point of visual abstraction. The dialogue is also extended through outer circles of associative material, such as testimonies of friends, fellow artists and doctors, or spectral medical images of Rodney's body. Despite *Autoicon*'s governing limits and rules, and its transparent artifice of conversation, throughout any exchange there are moments of profound and seemingly unprescribed confluence. In the exchange transcribed at the start of this chapter, the question 'How did your illness impact on your work as an artist?' generates a recording of Rodney addressing the dismissal of his work and that of other members of The Blk Art Group as 'propaganda'.[24] The response seems non-sequitous, yet could also be read as a resistance to the possessive 'your illness' as a presupposed formative condition for Rodney's

art production, instead implicating the propagation of lifestyle and wealth in the work of 'so-called Western artists' – a gesture towards the endemic disease of racial capitalism. The unpredictability of *Autoicon*'s responses is not driven by the game of simulating human thought, but instead draws on a life lived with and through others.[25] The user is confronted with the ongoing entanglement of identity and alterity.

The central chat function gradually layers the screen with a patchwork of overlapping windows. Accessing the 'Activities' drop-down from the menu bar allows the activation of a parallel function through the option 'View Montage'. Generating one larger image window overlaying the other pop-ups, this function produces a composite visual made from fragmented smaller images, rudimentary graphics and lists of computer file titles. In some cases, these deconstructed materials mirror those appearing in the background 'dialogue' with *Autoicon*: an X-ray image of a hand might re-appear spliced with a black-and-white close-up of Rodney with a cat or a video game graphic of Lara Croft from *Tomb Raider* (fig.10). Gradually, the montage autonomously transforms itself, as new distorted visuals start to emerge. As described in the sleeve notes, this 'auto-generative montage ma-.chine' actively pulls material from a computer's hard drive, trawling librar-ies and databases for suitable graphics based on keywords from the chat, along with those that exist in the CD-ROM's own database; or, in the case of the original online version, it drew from the incessantly expanding image bank of the Internet. Seemingly hardwired into this montage system is the exploitation of error, the faulty transposition and splicing of the digital code that makes up images, graphics or text, fragmenting their appearance and causing the emergence of background file names and html (fig.11).

The *Autoicon* montage machine has distinct correlates within particu-lar developments in net art in the 1990s and into the early 2000s. Artists producing work for and on the Internet in this period often sought to punc-ture the uniformity of the 'graphical user interface' – the mediative layer of symbols and icons through which users unquestioningly communicate with computers. In many cases, this appeared to the individual encountering the work online as error or breakdown; a loss of functionality or access to ex-pected information. Such interventions – in video gamer circles taken up as 'modding'[26] – made hidden pre-programmed patterns apparent to the user or repurposed them to new ends. In its most visual and process-oriented forms,

this distortive strand of digital art joined a lineage of earlier experimentation with analogue media, such as Nam June Paik's celebrated *Magnet TV* (1965). The embrace of visual artefacts produced through existing or introduced error in underlying digital code became known in the early 2000s as 'glitch art'.[27]

While the 'liquid' image generated by *Autoicon*'s montage machine appears formally similar to glitch art, its stated approach to montage – a perpetual aggregation and melding of digital media 'like a sketchbook of ideas in flux' – is less a technological disruptor than a corollary to analogue artistic praxis. As such, it points to developments in the tools of digital image processing and their application, as informed by the generation of particularly mobile and transformational aesthetic, cultural and political spaces. The artist Keith Piper has highlighted the importance in the 1990s of the multimedia authoring software Macromedia Director (used, in part, to build *Autoicon*) and its basis in the programming language Lingo, created by the Jamaican-American computer scientist John Henry Thompson. Applied within programmes such as Director, Lingo enabled an immediacy of interaction with and alteration of digital graphic objects – a polysemic structuring and strategic encoding of iconographic space and meaning that Piper links to black speech, and that was central to Piper's own practice as well as to a number of other black artists and organisations using digital media in this period. Proposed as a space of radical continuation and an extension of Rodney's creative practice, particularly his use of collage and cut-up, the *Autoicon* montage machine does not produce discrete objects. Rather, echoing the concept of 'gathering and re-using' articulated in 1988 by Rodney's friend and fellow artist Lubaina Himid, '[e]ach piece within the piece has its own history, its own past and its own contribution to the whole: the new function'.[28] The montage machine pulls from and constantly reconstitutes layers of material prescribed by multiple agents: Donald Rodney via Donald Rodney plc; the user and the contents of their hard drive; and the massed users and programmers of the Web. In this ever-evolving patchwork of simultaneously singular and collective digital traces, the 'glitch' is not only a formal conceit but an ontological condition, an immersion in 'positive irregularities'.[29]

Autoicon's montage machine is then, perhaps, less an affiliate of early millennial glitch art and more a precedent of Legacy Russell's recuperation of the term in 2020 under the banner of 'glitch feminism'. For Russell,

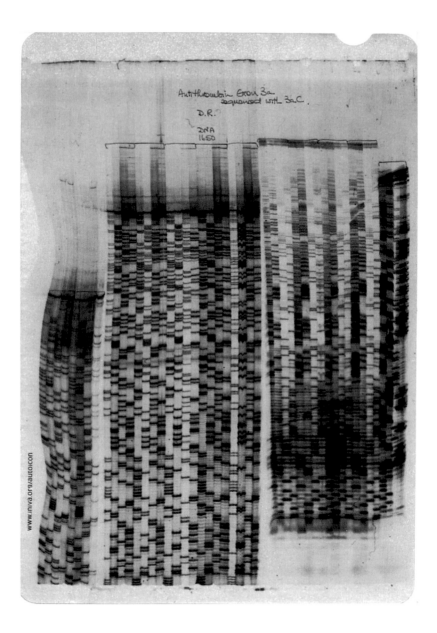

1. Invitation to launch of *Donald Rodney: Autoicon*, Web version, Institute of International Visual Arts (Iniva), 10 June 2000

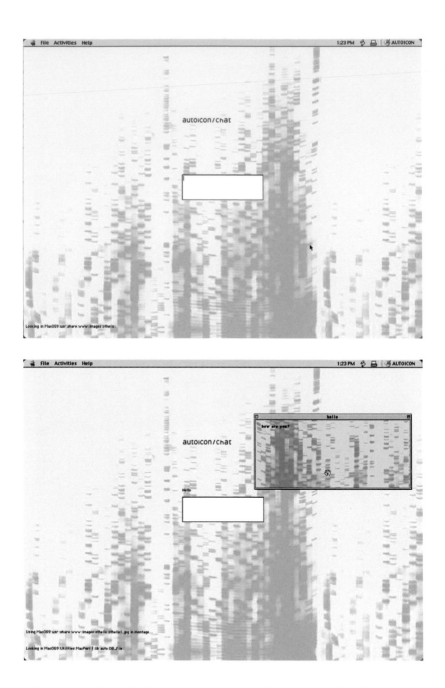

2. Landing page of *Donald Rodney: Autoicon*, 2000, CD-ROM version

3–9. Chat function of *Donald Rodney: Autoicon*, 2000, CD-ROM version

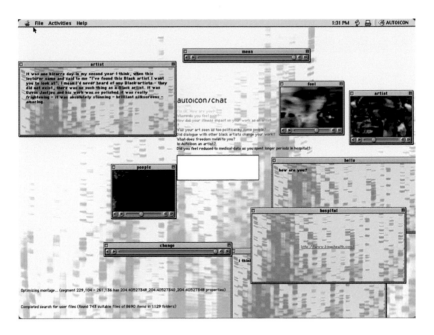

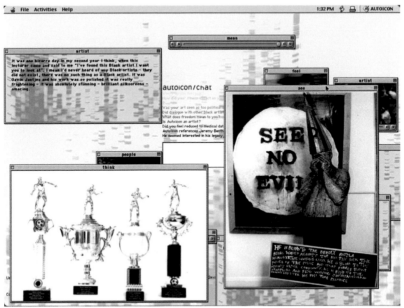

4, 5.

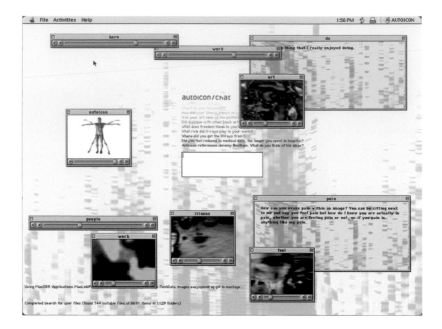

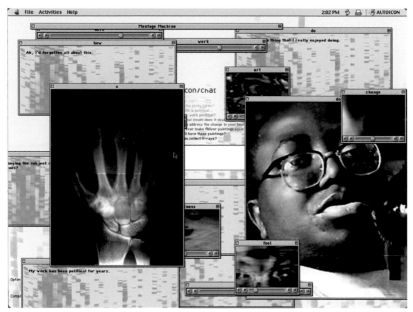

6, 7.

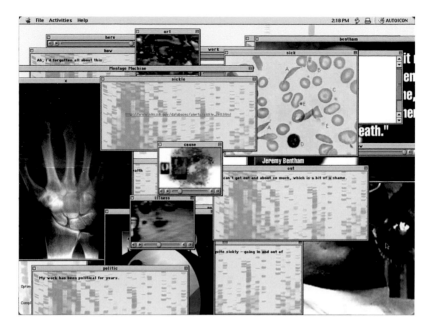

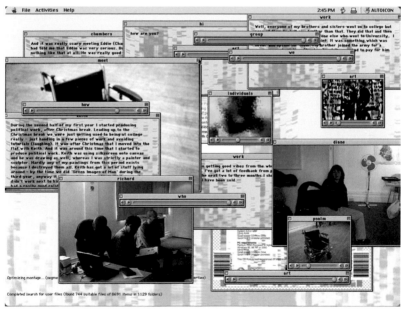

8, 9.

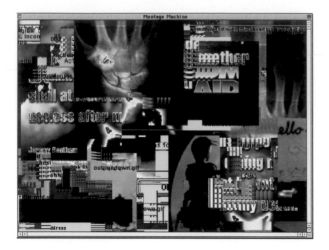

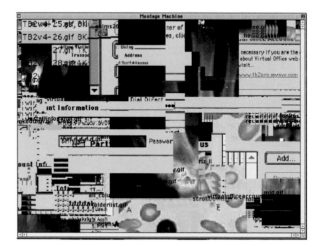

10-11. Montage function of *Donald Rodney: Autoicon*, 2000, CD-ROM version

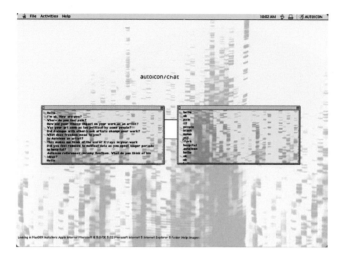

Above:
12. Memory function of *Donald Rodney: Autoicon*, 2000, CD-ROM version

Below:
13. Biography function of *Donald Rodney: Autoicon*, 2000, CD-ROM version

14. Menu page of *Donald Rodney:
Autoicon*, 2000, CD-ROM version

'glitch feminism' speaks to acts of 'imbuing digital material with fantasy' as survival mechanisms, and an online playfulness and experimentation with identity as much as with writing code, which strengthens 'the loop between online and AFK [Away From Keyboard]'. This in-between space is, for the glitch feminist, one of multiple selves, of gender as slippery and transitional, and of bodies with 'no single destination but rather ... a distributed nature'.[30] The glitch, or the act of glitching or being glitched, is understood here as both an assignation of error and a refusal to perform binary codes. In its contingent relations with users and in its crawling of html and its embedded images, *Autoicon*'s montage machine prefigures Russell's definition of the ongoing action of glitching as 'incessant cutting and stitching, breaking and healing, as it is afforded by the digital as performative material within the context of the everyday'.[31]

In addition to 'View Montage', the 'Activities' drop-down in *Autoicon* presents two further options: 'View Memory' and 'View Biography'. While suggesting similarly retrospective territories, these functions offer distinctive views. On entering 'Memory', an archive presents two scrollable text pop-ups: one containing the accumulating chat entries made by all *Autoicon* users (either those accessing the particular copy of the CD-ROM, or, when operational, the website), and the other the keywords linked to each of *Autoicon*'s responses (fig.12). 'Biography' takes a more institutionalised approach, transferring the user to a parallel platform organised along the lines of an artist's website (a form considerably less prevalent in the late 1990s than today) – with a biographical text by Eddie Chambers on Rodney and his work; testimonies from his friends originally delivered at Rodney's memorial; images of his work; transcriptions of three interviews; and video clips from TV programmes and video works featuring Rodney (fig.13). In both 'Memory' and 'Biography', the singularity of the user's engagement with *Autoicon* is pointedly dispersed, as one becomes aware of the content of other users' exchanges and one's own entries forming part of the growing programme database, parallel with the 'real world' sphere of Rodney's personal relationships during his lifetime. Chambers, in his biographical text, indicates the basis of *Autoicon* as a collective project of inquiry, memory, celebration and critical speculation in the particular conditions of Rodney's life: 'By the mid 1990s Donald had, with the help of his partner Diane Symons and close friends and fellow artists such as Virginia Nimarkoh, perfected

his ability to direct and produce a range of work from his hospital bed. ...
Autoicon marks the fulfilment of Donald's collaborative process.'[32]

The presence of 'montage', 'memory' and 'biography' as attendant functions to the main exchange between *Autoicon* and its user speaks to the methodological basis of the work in critical approaches to intertextuality. The three functions work through levels of cross-iteration, repetition and cut-up: the videos in 'biography' are filtered, clipped and categorised by keywords to reappear as content in *Autoicon*'s conversational lexicon; the rich play of image, text and sound in this lexicon is transposed in 'memory' into an enigmatic, poetic list of keywords. Reading between the two windows of the 'memory' function, against the cacophonous backdrop of Rodney's voice, transcribed words and data-mined body, the user becomes aware of the multiple interactions and layered histories that compose *Autoicon*'s keyword structure. In an early meeting of Donald Rodney plc, discussing the natural language processing that would enable *Autoicon* to break down the grammatical structure of a user's question and build a response based on keywords and the storing of previous dialogues, Piper noted: 'If you've got ... quite a small range of answers then you will quickly tie it into knots; the larger the range the longer it will take you to detect that you are talking to a machine.'[33] The 'memory' function exposes this acquisition of 'range' as a product of a looping and self-referencing system – a recursive mode of algorithmic learning, dependent on the acquisition of masses of data, which has become increasingly familiar over the last two decades.

As such, *Autoicon*'s textual and technological character recalls Katherine McKittrick's reflections on creative texts that engage and uncover autopoietic and recursive social systems. Drawing from research examining lexical networks, McKittrick references the notion of 'diachronic loops' – 'clusters of words, definitions and concepts that are introduced into the system at different times and thus hold in them the possibility to question its coherency yet remain verifiable within the context of the broader lexicon'.[34] She applies this notion to her reading of M. NourbeSe Philip's seminal poem *Zong!* (2008), an 'extended poetry cycle' that draws on and fragments the text of *Gregson v Gilbert*, a 1783 court report on a disputed insurance claim made following the deliberate drowning of 150 enslaved Africans during their forced transatlantic passage onboard the ship Zong. In *Zong!*, Philip spaces words across the page, removing linearity and horizontality and in-

stead emphasising multiple possible vectors of reading. The poem treats the legal report as a 'word store', transforming it into a cacophony of 'mutter, chant and babble', and implicating the reader in the resurfacing of lost voices.[35] In *Autoicon's* 'memory', a kindred clustering and scattering of words, voices, looping concepts and histories can be seen, built around the mediatised documents of Rodney's life, and yielding what McKittrick terms a 'creative text [that] if read through the lens of black life and livingness, reveals a diachronic loop that undoes a biocentric logic by naming it and, simultaneously, demanding the reader contend with the ability for this logic to sustain itself'.[36]

Despite the onus on the *Autoicon* user to individually activate each of its functions, there is no prescribed route through the interweaving transmissions of 'chat', 'montage', 'memory' and 'biography'. Its quadripartite structure emphasises multiple inter-subjective and intra-actional layers of witnessing, while implicating the contemporary ruptures at play in testimony's mediation through digital media, informational networks, artificial thinking and the recuperations of data science. *Autoicon* stridently demands an understanding of such developments within wider historical and mythological frameworks of the technologies of the self, the political and the social role of memory, and experiences of the body and of embodiment. Across its multiple points of entry, the user might perceive what Jean Fisher describes as the capacity of testimonial memory to disturb the official narratives of the archive through what is left unsaid as much as what is said – or, in her phrasing, 'the fragile interval between speaking and not being able to speak'. [37]

The software

A curious question might be mooted. A man's Auto-Icon is his own self. May not a man do what he will with his own? with his own property? Yes! With his own person? Yes! ... With his own body? Yes! ... So many uses as an Auto-Icon is capable of being put to, – so many shapes in which it is capable of operating as a benefit, – so many characters in which it is expressive of being a subject-matter of property, and as such of law and legislation. A spick and span new subject-matter of property is brought for the first time into existence ...
– Jeremy Bentham[38]

In a talk delivered during Donald Rodney's posthumous exhibition at Iniva in 2008, Virginia Nimarkoh reflected on the artist's vast collection of art books and his habit of signing his name on the inside cover of each in black marker pen. For Nimarkoh, a close friend of Rodney's, the habit was irritating in life but in the aftermath of his death 'a reassuringly defiant sign that he lived'.[39] She noted how, for the bookseller who acquired part of Rodney's collection, the signatures represented an impediment to future sales, but speculated that there may come a day when the autographs, found in books scattered amongst many owners, will significantly increase their value. Nimarkoh's reflections illuminate the precarity of 'legacy' and the complexity of Rodney's acts of autography: as declaration of artistic presence and claim on property; as speculation on a future of bodily absence and 'viral' remembrance; and as intervention into the ongoing construct of history. Rodney's act of signing his books stands as one of defiant inscription, yet it also highlights the ultimately manifold circulation of the signature beyond its original moment of production. As Jacques Derrida – the arch-deconstructionist of the effects of signature – remarked:

> *In order to function, that is, to be readable, a signature must have a repeatable, iterable, imitable form; it must be able to be detached from the present and singular intention of its production. ... To write is to produce a mark that will constitute a sort of machine which is productive in turn, and which my future disappearance will not, in principle, hinder in its functioning, offering things and itself to be read and to be rewritten.*[40]

As a 'machine which is productive in turn', produced under the signature of Donald Rodney but with the knowledge of its realisation only in the event of his disappearance, *Autoicon* can be seen as an extrapolation of critical questions around legacy, presence, identity and history. In its very proposition, *Autoicon* problematises the notion of individual identity tied to artistic production, in that it sets itself up not as self-portrait, nor even as portrait composed of remnants or artefacts of the self, but as the 'self' preserved and re-actualised through a poly-vocal endeavour – that of both Donald Rodney plc and any user of the programme.

'The logic of identity is the logic of something like a "true self",' wrote Stuart Hall some ten years prior to *Autoicon*'s publication. 'Identity is a narrative of the self; it's the story we tell about the self in order to know who we are.'[41] *Autoicon* is a complex and decisively non-monolithic narrative machine, yet it is also haunted by a very particular conception of the 'true self': that of Jeremy Bentham's Auto-Icon. During Rodney's lifetime, Bentham's utilitarian philosophy achieved new notoriety through Michel Foucault's writing on the Panopticon – Bentham's invention of a prison architecture rooted in surveillance and self-surveillance – and how it shifted the historical locus of power from the sudden violence of the monarch to a subtler infusion in 'the very foundations of society'.[42] While less pored over than the Panopticon, Bentham's Auto-Icon serves as a parallel technological speculation on the biopolitical, one that seeks to resolve the lingering problem of the sovereign self and the forces it holds and is subject to, both internal and external to the body. It belongs to what Foucault described as 'technologies of the self': techniques which 'permit individuals to effect by their own means or with the help of others a certain number of operations on their own bodies and souls, thoughts, conduct, and way of being … in order to attain a certain state of happiness, purity, wisdom, perfection, or immortality'.[43]

Rodney's reference to Bentham's Auto-Icon is more than a tipping-of-the-hat to a historical precursor. In his use of imagery and language – from his choice of titles to his text-heavy assemblages of the mid-1980s – Rodney's works often critically draw on the material and symbolic grammar of British colonial and imperial history, and its outgrowth from a theological rhetoric of family, home and body. In parallel, the construct of the reflexive self and its representation features prominently in his practice from the late 1980s on, in pointed lockstep with the coding of the body.[44] Seen within this wider

context, the historical oddity of the Auto-Icon plays a dual role as the ground on which *Autoicon* is set. Firstly, it serves as a technological antecedent of the late-twentieth-century transhumanist promise of digital networks to surpass the mortal subject. In adopting Bentham's concept of extending personhood beyond death through the substance of 'his own self', rather than through mere representation, *Autoicon* functions as a palimpsest, a digital overwriting of Bentham's corporeal conception of auto-iconography. Secondly, connected to this lingering imperative to transcend the human body, the concept of auto-iconography acts as a prism through which to critically engage European modernity's writing of the self-determined, interior subject – a productive force that continues to define notions of humanity and conditions of globality. Even in the grammatical shift from the hyphenated neologism 'Auto-Icon' to its echo in the closed compound 'Autoicon', which fictitiously suggests a familiarity of usage in the intervening 165 years, Rodney's work emphasises Bentham's gesture as genealogically bound to the discursive and material present. Through points of contact and dissent with Bentham's vision – from the body as both constituted and fragmented by scientific analysis, to interlocution as a paradoxical force of affirmation and dispersion of identity – *Autoicon* establishes a set of critical relations that refract across Rodney's wider practice.

Bentham's life, from 1748 to 1832, spanned a period in which shifting conceptions of individual autonomy and sovereignty were inscribed within the emergence of increasingly global orders of power and value. In her close reading of key texts of Enlightenment and post-Enlightenment philosophy and science, scholar and artist Denise Ferreira da Silva traces connections between the writing of self-consciousness in European modernity, constructions of globality and the role of race within a modern economy of signification. She has demonstrated how, 'by tying certain bodily and mental configurations to different global regions', the 'arsenal' of tools of European philosophical and scientific knowledge produced two kinds of modern subjects: 'the subject of transparency, for whom universal reason is an interior guide, and subjects of affectability, for whom universal reason remains an exterior ruler'.[45] Da Silva's analysis shows the extent to which this arsenal centred the deployment of the racial, with 'the transparent I' (the figure of 'Man') invariably located in Europe, and dependent in its conception on the parallel writing of the 'others of Europe'. In this light, Bentham's Auto-Icon,

with its treatment of body and identity wrapped up in political, economic and juridical schemas, can be read as one such text, which inscribes racial and cultural difference in the forceful production of globality.

Da Silva also contests the 'death of the subject', its late-twentieth-century dissolution into postmodern plurality: 'the subject may be dead ... but his ghost – the tools and the raw materials used in his assemblage – remain with us'.[46] The presence of Bentham's Auto-Icon as a model for Rodney's *Autoicon* instigates and necessitates attentiveness in the user to the persistence of such 'tools and raw materials'. As with other statues, memorials and openly displayed historical artefacts, the ongoing publicness of the Auto-Icon speaks not merely to the representation of history, but to the symbolic and material forces through which it actively conditions the world around it. As 'software', Bentham's Auto-Icon stands for a system of calculus and equivalence, conditioning the recursive flows of racial capitalism that Rodney's work consistently challenges. *Autoicon* sets in motion a genealogical encounter with the Auto-Icon and the context of its emergence as a means to interrogate the 'technologies of the self' of modernity, and their entanglement with the manipulation and production of 'othered' bodies – what da Silva terms the 'analytics of raciality'.[47]

'... a man who is his own image'

In a will written in 1769 at the age of 21, Jeremy Bentham is said to have left his body to his friend Dr Fordyce for the purposes of anatomical dissection after his death. At a time when in Britain the only human corpses available to physicians and medical students for research purposes were those of convicted and executed murderers and those exhumed illegally by notorious individuals labelled 'resurrection men', such an instruction was radical yet in keeping with Bentham's utilitarian principles. Against a backdrop of heightened anxieties around grave robbers and physicians 'playing God', Bentham was committed to the scientific utility of the body throughout his life.[48] Yet by the time he wrote his penultimate will in 1824, and in drafting its final modifications in 1832, his instructions had substantively changed. Annexed to his will under the title 'Auto-Icon', a paper written with his friend Dr Thomas Southwood Smith outlines '[t]he manner in which Mr Bentham's body is to be disposed of after his death', which was to include a series of public lectures illustrated by the body's dissection. After the lectures, Southwood Smith was

to prepare the organs 'in whatever manner may be conceived to render their preservation the most perfect and durable'. Bentham instructed that

> [t]he Head is to be prepared according to the specimen which Mr Bentham has seen and approved of. ... The skeleton he [Southwood Smith] will cause to be put together in such manner as that the whole figure may be seated in a Chair usually occupied by me when living in the attitude in which I am sitting when engaged in thought in the course of the time employed in writing I direct that the body thus prepared shall be ... clad in one of the suits of black occasionally worn by me. ... And for containing the whole apparatus he will cause to be prepared an appropriate box or case and will cause to be engraved in conspicuous characters on a plate to be affixed thereon and also on the labels on the glass cases in which the preparations of the soft parts of my body shall be contained ... my name at length ... followed by the day of my decease. ... If it should so happen that my personal friends and other Disciples should be disposed to meet together on some day or days of the year for the purpose of commemorating the Founder of the greatest happiness system of morals and legislation my executor will from time to time cause to be conveyed to the room in which they meet the said Box or case.[49]

Following Bentham's death, Southwood Smith completed his instructions with one crucial variation. The attempt to preserve the philosopher's head by applying the drying methods of the Māori in their practice of *mokomokai* was unsuccessful,[50] and as a result a waxwork likeness was commissioned from the French physician and anatomical model-maker Jacques Talrich.[51]

While it has been argued that Bentham's Auto-Icon was the ultimate realisation of a lifelong repudiation of religion, and that in leaving his body to medical science he rejected the existence of such a thing as a soul housed within the body, the changes in his will between 1769 and 1824 reveal a later foregrounding of a posthumous utility for both his corpse and his identity. By the time of his death, Bentham's focus was no longer simply on the body as 'material' for scientific research, but also on the physiognomic preservation of his personhood as a bearer of specific knowledge and character, to be operatively maintained into the future. In the years preceding 1832, he had

privately penned the manuscript 'Auto-Icon, or, Farther uses of the dead to the living', outlining in detail his concept of auto-iconography as a technology to be widely taken up for the improvement of mankind. The text articulates the utility the dead might provide the living through the proposition of two 'objects': '1. A transitory, which I shall call anatomical, or dissectional: 2. a permanent – say, a conservative, or statuary.'[52] While the former object is seen to be of benefit through both the acquisition of medical knowledge and the avoidance of disease and expense associated with poor burial practices, the latter provides the greatest focus for Bentham, building on the proclamations that 'now may *every man* be *his own statue. Every man is his best biographer.*' He found common cause with the literary form of the autobiography and the act of autography: 'The word *auto* has been made familiar to English ears by its use in autobiography, (why should there not be *auto-thanatography?*) *auto*graph, &c. Auto-Icon will be soon understood for a man who is his own image.'[53]

Bentham cited eleven uses for such 'auto-thanatography', including 'Moral', 'Political' and 'Economical'.[54] He treated the Auto-Icon as object ('moulds for the creation of perfect and economical busts'), but also as an instance of property interchangeable with the self, akin to the development of patents as a form of intellectual property in the late eighteenth century ('A man's Auto-Icon is his own self. May not a man do what he will with his own? with his own property? Yes!'[55]) In the face of death, Bentham walked a curious line, at times in alignment with and at others in contravention of a mind-body dualism. While he did not suggest that the workings of the mind are present in the Auto-Icon, he postulated a transcendent persistence of identity as held within the 'statue', surpassing mere memorialisation. In the Auto-Icon's projection into the future, Bentham saw a test of moral character and greatness that is transhistorical: he speculated on how a person perceived to be dishonourable during their lifetime might be re-evaluated by future generations through their Auto-Icon; proposed theatrical discourse between Auto-Icons (an extended segment imagines Bentham in conversation with classical and Enlightenment philosophers); and suggested the physiognomic value of Auto-Icons as specimens for 'anatomico-moral instruction'. His request for his Auto-Icon to be present at occasional meetings of his 'disciples' shows awareness of the life of his ideas beyond death and the weight his physical body might lend to this ideological extension. In line with the na-

scent sciences of psychology and sociology, Bentham's essay characterises the human mind as subject to external knowledge and affect, but capable of achieving a state of transcendent self-actualisation and interiority through progressive rational activity in society – the position of the bourgeois, male, European subject; that is, the sovereign individual.

Bentham's emphasis on the beneficent and prudent character of auto-iconography draws on the social role of individual self-interest and self-ownership as outlined within the emergent 'science' of political economy in the late eighteenth century. The influence of Adam Smith's ideas, which were taken on by Bentham and his fellow self-appointed Philosophical Radicals (most notably, David Ricardo), is evident in nineteenth-century arguments for a free market economy over mercantilism, which led to the breaking of the West Indian sugar monopoly.[56] It is also present in Bentham's utilitarian position on the abolition of slavery in the British colonies, which he supported only on the basis that 'instead of rendering emancipation burdensome to the master, it ought, as much as possible, to be rendered advantageous to him'.[57] Bentham's desire would be realised in 1833, a year after his death, in the passing of an abolition bill that included £20 million in compensation for to the former owners of enslaved people.

In the archive of Donald Rodney's reference papers and sketchbooks held at Tate Library in London, an undated letter from a friend – seemingly on a research mission requested by Rodney – includes a xeroxed copy of Scottish critic Thomas Carlyle's 1849 invective 'Occasional Discourse on the Negro Question',[58] a proto-fascist text advocating for the enforcement of servitude on black communities in the West Indies, which Carlyle deemed necessary on the grounds of racial inferiority. Trafficking in gross racial stereotypes, the wider context of the essay was Carlyle's support for West Indian plantation owners and his antagonism towards abolitionists and free trade economists seeking to end both international slavery and restrictions on colonial trade. In the latter camp, Bentham's former pupil and torch-bearer of utilitarianism John Stuart Mill penned a public response to Carlyle, admonishing him for committing the 'vulgar error of imputing every difference which he finds among human beings to an original difference of nature'. Instead, Mill asserted that 'spontaneous improvement, beyond a very low grade improvement by internal development, without aid from other individuals or peoples is one of the rarest phenomena in history'.[59] Perhaps the

most telling aspect of this exchange is not Carlyle's amplification of Victorian tropes of racial hierarchy, but Mill's no less racist utilitarian understanding of improvement and development of individual and national character – an understanding he expressed both theoretically and in a practical capacity over his 35 years working for the East India Company during the indirect rule of India.[60] The enmeshment of knowledge, wealth and morality constituted for Mill and Bentham the very terms of 'civilisation' upon which individual liberty depended – as such, their vision of liberal capitalism was based on the imperialist writing of regional and racial difference.

For his 1974 film *Figures of Wax (Jeremy Bentham)*, made while he was teaching at University College London, the artist Marcel Broodthaers spliced footage of Bentham's Auto-Icon, resplendent in its wood-and-glass display case in the cloisters of UCL (founded in 1826 by Bentham acolytes), with images from around London including street views of the former London Stock Exchange, a discount shop window and mannequins at Selfridges department store. Shot preceding the 1974 elections in the UK, in the midst of an economic recession and a three-day work week mandated by the Conservative government in response to striking coal miners and railway workers, *Figures of Wax* implicates Bentham's Auto-Icon as an object of value, a commodity fetish of sorts and a historical totem of a politico-economic ideology still discharging its effects into the world. In *Capital: A Critique of Political Economy* (1867), published 35 years after Bentham's death, Karl Marx sarcastically summed up the exchange between worker and capitalist as 'a very Eden of the innate rights of man. There alone rule Freedom, Equality, Property and Bentham.'[61] But reducing Bentham to a principle of 'each looks only to himself'[62] inadvertently overlooks some of the more significant ways in which he exemplifies the durable intersections of selfhood, morality, science and political economy that arose in nineteenth-century Europe and coalesce in the Auto-Icon. Close to midway through the film, Broodthaers is pictured in conversation with the Auto-Icon, a soundless 'exchange' with just the artist's words posted as subtitles: 'If you have ... / a statement to make ... / please do so ... / if you have a secret / ... tell me / ... or a special message / give me an indication / ...'[63] Bentham's immobile wax features exemplify the silence of history, yet equally historicity's ghostly power as a discursive and material force born in the assemblage of the subject of European modernity.

'me ... not me ... me again'

Life and death appeared to me ideal bounds, which I should first break through. ... A new species would bless me as its creator and source; many happy and excellent natures would owe their being to me.
- Mary Shelley[64]

For '9 Night in Eldorado', his 1997 exhibition at South London Gallery, Rodney walled off the rear section of the gallery, creating a long, dark corridor. At its end, he positioned *Pygmalion* (1997, fig.16), his remake of a fairground automaton in a glass case (an attraction from the lineage of Roger Bacon's 'brazen head' and Bentham's Auto-Icon) illuminated only by internal lights.[65] Whereas the automaton would originally have taken a coin to activate movement, Rodney fitted *Pygmalion* with a sensor to respond to approaching viewers. The figure inside the case – whose torso, arms and head jerk jarringly back and forth in the presence of a viewer – he customised with the unmistakeable Napoleonic military jacket, curly-perm hair and single rhinestone glove of the popstar Michael Jackson. But rather than the face of the 'King of Pop', who achieved global renown in the 1980s and 90s, the automaton's head is made-up in the blackface of minstrelsy. Rodney had long been interested in Jackson's treatment in the British press, and he collected newspaper clippings over many years. The theatrical horror of *Pygmalion* implicates the ways in which the musician's appearance and behaviour had been stigmatised in the mould of a Victorian sideshow. The assertion of constructions of race, gender and sexuality was central to this sustained tabloid narrative, a backlash against Jackson's perceived cultural and physiological mutability. In a 1985 essay on androgyny, James Baldwin wrote about how the cacophonous public characterisation of Jackson

> *is fascinating in that it is not about Jackson at all. ... All that noise is about America, as the dishonest custodian of black life and wealth; ... and sex and sexual roles and sexual panic. ... [F]reaks are called freaks and are treated as they are treated – in the main, abominably – because they are human beings who cause to echo, deep within us, our most profound terrors and desires.*[66]

The work's title, *Pygmalion*, roots it in relation to a specific trajectory of Western classical thought. In Ovid's telling of Greek mythology, Pygmalion is a sculptor who, having sworn himself to celibacy after coming into contact with the libertine daughters of Propoetus, falls in love with his own statue of a girl. The goddess Venus grants Pygmalion's wish for the statue to become his bride, and she comes to life upon his kissing the ivory form. The myth had a great appeal in late-eighteenth- and nineteenth-century European cultural circles: Jean-Jacques Rousseau, Johann Wolfgang van Goethe and Friedrich Schiller all produced plays, ballads and poems based on the story. In Rousseau's 1762 melodrama *Pygmalion* – written the same year as his *Social Contract* – the moment of the statue's awakening is marked by her touching herself and saying 'me', then touching a nearby sculpture and saying 'not me', and finally reaching out to Pygmalion saying 'me again'.[67] The Ovidean tale of divine grace providing life was transformed into a secular metaphor for identity and sameness as egalitarian force, and for the transcendental artistic power of the imagination. In 1913, George Bernard Shaw inverted the myth into a satire of social betterment and gender relations, as a man endeavours to turn a woman into an automaton of upper-class vocal mimicry.

In Rodney's *Pygmalion,* a similar inversion is performed as Jackson is rendered as crude automaton, his proficiency as dancer, singer and musician reduced to three silent, robotic upper-body movements. The use of blackface centres the contradictions and cultural pathologies of whiteness as they have played out in the mainstream reception of Jackson as an artist and celebrity. The horror of minstrelsy – still performed weekly on national television in the UK until the late 1970s – and its roots in antebellum America is described by scholar Saidiya Hartman as

> *restaging the seizure and possession of the black body for the other's use and enjoyment. … In blackface, as elsewhere in antebellum society, the fashioning of whiteness in large measure occurred by way of the subjugation of blacks. The illusory integrity of whiteness facilitated by attraction and/or antipathy to blackness was ultimately predicated upon the indiscriminate use and possession of the black body.*[68]

Extending from the messianic to the monstrous, the hysteria that surrounded Jackson during his lifetime underscores the dialectic of attraction and an-

tipathy to blackness that Hartman identifies in whiteness, as a persistently dispossessive cultural and material force. The 'performance of blackness' in minstrelsy speaks to the wider fixing of blackness under the burden of being in 'the live', a denial of both history and futurity.[69]

In the years preceding Rodney's production of *Pygmalion* in 1997, Jackson was touring the album *HIStory* (1995), with concerts publicised by the appearance of thirty-foot-tall statues of the musician at ten locations globally, including on the River Thames in London. A teaser film notoriously captured the unveiling of one such statue, with fans exclaiming 'Michael, we love you!' at its feet. Rodney's *Pygmalion* tellingly adopts a classical myth of creation based on illusion and misidentification, but also on a construction of gender and sexuality wherein the animated statue serves as a surface of projection. Jackson's body – in public consciousness seen as transitional, whether as a result of facial surgery or the use of skin-whitening creams – is to be read as an ethical allegory, a vehicle for both white self-exploration and a fixing of blackness. It is perhaps significant that Rodney chose a hairstyle and clothing that date the model for his automaton as Jackson's early 1990s public persona – a period in which popular pluralism was considered to be loosening the boundaries of identity. In this moment of cultural fluidity, Jackson stood as an example of the re-assertion of racial logics between two poles of black identity perceived as social and political category: an 'unashamed essentialism', which called Jackson out for his perceived desire to achieve fame through 'becoming white', and a 'would-be postmodern pragmatism', which reduced Jackson first to his body and then to an 'emphatically' disembodied image.[70]

Alongside its resonance for late-Enlightenment thinkers, the Ovidean myth of Pygmalion held potency for the early Romantics as questions of life, consciousness and selfhood were debated across philosophy, science and art. In synthesis with the myth of Prometheus – the god who in Ovid's telling formed humans from clay and stole the technology of fire from Zeus, gifting it to humanity as the spark of civilisation – Pygmalion is thought to have been a key reference point for Mary Shelley's 1818 novel *Frankenstein; or, The Modern Prometheus*. Shelley's gothic horror story plays out the thought experiment of the inanimate brought to life, and its gradual acquisition of knowledge and a sense of self through sensory experience and language. In a doubling of the Pygmalion myth, not only does Victor Frankenstein's singular drive yield the transformation of body parts into an animate 'monster',

but the monster itself becomes governed by the desire for a companion in his own likeness, making the monster dependent on Victor Frankenstein to repeat the feat of animation. Shelley, however, cast her Pygmalion in a contrary light to Rousseau's artist: Victor Frankenstein is a rationalist, even perhaps a utilitarian. His fate, seen alongside the novel's treatment of the almost heroic drive for the humanity of the monster, is at once to be the 'victor' - the bearer of a godlike power, through scientific knowledge - and to be righteously destroyed by that which he created.

A copy of *Frankenstein* is listed in Nimarkoh's 1997 inventory of the books, magazines, CDs, films and computer games stored close to Rodney's hospital bed. Tellingly, Rodney's preparatory notes for *Pygmalion* include a series of transcribed passages from a 1996 Open University television documentary on *Frankenstein:*

> *The creature is the other beyond and the outsider a monster without control of his identity; anger at the betrayal of the body ... the monster has appropriated the master's name ... it creates a debate about difference ... the exterior being not an indication of the interior.*[71]

If Rodney's *Pygmalion* draws out the popular media's rendering of Jackson as a 'monster without control of his identity', the technical apparatus of the automaton implicates the history of scientific approaches to life as an operative force in the writing of the 'self-determined subject and its outer-determined other'.[72] Shelley's introduction to the 1831 edition of *Frankenstein* tells of writing it as a ghost story inspired by conversations with Percy Bysshe Shelley, her husband, and Lord Byron on 'various philosophical doctrines ... among others the nature of the principle of life'.[73] Victor Frankenstein's character and experiments appear directly related to notable physicians of the time, such as Erasmus Darwin and Luigi Galvani, and perhaps indirectly William Lawrence, the Shelleys' friend and personal physician. Lawrence aligned the empirical observation of variations within species of animals with a concept of racial difference and hierarchy in humans, as did his French contemporary the zoologist Georges Cuvier and, later, Charles Darwin. Through the latter three thinkers' formative theories, certain 'laws of nature' came to be widely understood across nineteenth-century Europe as regulating human conditions and defining distinct kinds of human beings

in each global region – but with the figure of 'civilised man' uniquely placed outside the constraint of these laws. In *The Descent of Man, and Selection in Relation to Sex* (1871), Darwin firmly associated this figure with the 'high intellectual and moral faculties' of post-Enlightenment Europe, predicting that '[a]t some future period, not very distant as measured by centuries, the civilised races of man will almost certainly exterminate, and replace, the savage races throughout the world'.[74] While *Frankenstein* is often held up as a cultural cipher for eschatological fears of the scientific and technological mastery over life, in its relation to the emerging sciences of man, like Bentham's Auto-Icon, it is also connected to the production of the racial as scientific and cultural signifier projected on the global stage.[75]

In his sketchbook entries and early works – from *Brown Coloured Black* (1983) to *Self-Portrait: Black Men Public Enemy* (1990) – Rodney emphasised the persistence of physiological understandings of racial difference as entwined with the production of scientific, cultural, social and economic knowledge. In the opening pages of a sketchbook from 1985,[76] he rendered a fractured and partial 'Royal Family Tree', beginning with Henry VII and ending with Charles I, and seemingly focussing on two dynastical schisms, the passing of the throne from the Tudors to the Stuarts and from the Stuarts to the Hanovers, that demarcate the first two hundred years of English colonialism. Each entry on the tree is accompanied by the rubbing of a coin, on top of which Rodney marked in white paint a nought or a cross (fig.15). On a following page he returned to the genealogy theme by noting and partially striking out a title: 'The family tree (Genealogical Table Showing the Descent ▬▬▬▬▬)'. In this instance, rather than a diagram of family relations, Rodney wrote out a number of entries under the heading 'The Human Race', each quoting historical racial typologies and accompanied by the brief citations 'according to Boyd' and 'according to Encyclopedia Britannica'. The latter source was a mainstay of the taxonomic aggregation and dissemination of knowledge since its first edition, published in Edinburgh in 1768.[77] The more obscure reference to 'Boyd' is likely to William C. Boyd, an American physical anthropologist who used research into blood groups in the 1950s to impose racial delineations on populations, and whose work formed the basis of *Races and People* (1955), an 'educational' book for teenagers co-written with Isaac Asimov.[78] Placed next to each other across consecutive sketchbook pages, the relationship between the 'Royal Family Tree' and the anthropological 'family

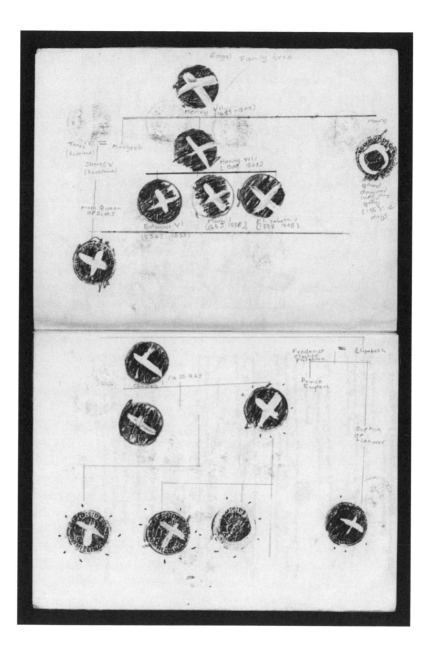

15. Donald Rodney, Sketch of royal
family tree in *Sketchbook No.8*, 1985,
graphite and correction fluid on paper,
225 × 175mm. Photo: Tate

tree' of the human race is pointed. The first drawing elaborates a genogram with frottage coins and paint marks, suggesting an opaque coding of hereditary patterns in which wealth and title are the consistent denominators. In the following transcription of a 'Genealogical Table', Rodney's striking out of part of the title shifts the emphasis away from Darwinian evolutionary ancestry to a sense of decline – the singular lineage of a monarchic line is set in relation to the corrosive ideological stage of globality and racial hierarchy. Together, the sketchbook pages push the disciplinary certitude of historical genealogy, physical anthropology and serology – the 'family tree' – into an excess of relations between language, signifier, index, line, gene, blood, exchange and erasure. These drawings – which could also be seen as experimental texts – are at once a critical dissolution of the taxonomic organisation of racial signifiers within discourse, and a troubling of the casting of racial difference as a merely symbolic aid to other mechanisms of exclusion – class, gender and economic status. As in *Autoicon*, the genealogy that Rodney put to work in his practice is not ordered around the (European) transcendental subject of development or succession; rather, it looks to critically picture the discursive and material forces through which self-images, identities and physical bodies are shaped. As such, it poses a question analogous to that framed by Katherine McKittrick, herself echoing Frantz Fanon: 'How might we think about the social construction of race in terms that notice how the condition of being black is knotted to scientific racism but not wholly defined by it?'[79]

'when one consents not to be a single being'

Reflecting on *Autoicon*, Donald Rodney's collaborator Mike Phillips describes two particular factors that lent weight to the work's conception: firstly, that during the course of their friendship Rodney informed Phillips that his life expectancy, as someone living with sickle cell anaemia, was around 36 years; and secondly, that the early 1990s saw a number of media arts projects that sought to realise forms of avatar within a nascent 'cyberspace'.[80] While influenced by William Gibson's *Neuromancer* (1984), the 'pale' avatars of the mid-90s could hardly match that novel's depiction of a space where, in literary critic Larry McCaffery's words, 'data dance with human consciousness, where human memory is literalized and mechanized, where multi-national information systems mutate and breed into startling new structures whose beauty and complexity are unimaginable, mystical,

and above all nonhuman'.[81] As Phillips remembers, 'there was something ghostly and hollow about these apparitions, they were, for the most part just pixels, vague representations that could neither feel nor be felt'.[82] In its basis in Rodney's 'body of work and body politic', *Autoicon* was intended to bypass these issues. Yet, I would argue that this aspiration was not simply to create a 'better' avatar – an upgrade of Bentham's Auto-Icon to mark over 150 years of techno-scientific 'progress' – but to interrogate and reformulate the dominant instantiations of the human as embodied in the figure of post-Enlightenment 'Man'. Contrary to Bentham's vision of auto-iconography, the 'self' of Donald Rodney, as materialised in *Autoicon*, is not maintained as an extension of intellectual property, a defiant circumvention of the limits to human life, or as an exemplification of individual freedom or greatness. Posing, to *Autoicon*, the question 'What does freedom mean to you?' might generate Rodney's voice answering 'Like, I'm trying to be an artist.' The figure of liberty, encapsulated in the zenith of artistic expression and creativity, is – in this artificial exchange – grounded by the livingness of 'trying to be'. For Rodney, this was not an expression of ambition but a reality of his circumstances, bound by the finitude of life expectancy and constructs of capacity. While Bentham foresaw, perhaps optimistically but ultimately correctly, beyond his death the ongoing presence of his Auto-Icon alongside the ever more detailed analysis of his life's work,[83] Rodney's *Autoicon* attends to a very different conception of life-work, wrapped up in an informatic and fabulatory body. In a *détournement* of Gibson's vision of cyberspace, this conception is intrinsically linked to an expression of black and diasporic life as always already startling, multiple and complex, simultaneous to its historical and durable coding as 'nonhuman'.[84]

In his work, Rodney related the diasporic experience to the displacements of the transatlantic slave trade; to his family history of migration; to the cultural and political identity of black British life; and, in the later years of his life, to the heterotopic possibilities held within the digital 'multiverse'. For philosopher and poet Édouard Glissant, the diasporic experience of translocation, resting on the moment of departure, is intrinsically linked to 'the passage from unity to multiplicity'. The departure that *Autoicon* signifies and comes into being around can similarly be understood, in Glissant's vastly resonant words, as a 'moment when one consents not to be a single being and attempts to be many beings at the same time'.[85] The notion of consent holds deep reso-

nances when interacting with *Autoicon*, and when interpreting those interactions, built both on algorithmic artifice and artefacts. In an echo of Rodney's *Pygmalion*, hovering in the background of the user's interaction is always the spectre of whiteness and its constitution of a false unity of self through the 'indiscriminate use and possession of the black body' – a condition that Hartman also links to white conceptions of liberty.[86] On a more foundational level, the question of consent was intimately at play in the work undertaken by Donald Rodney plc. The group – whose nomenclature ironically evokes the corporate legal structure of limited liability, itself an invention of colonial and racial capitalism – by necessity wrestled with consensus, responsibility and multiplicity in progressing Rodney's conception of the work in his absence. Fundamentally, therefore, the work traces layers of labour, interdependency, exchange and memory, laying bare the entanglement of the production of things, services and subjects with the production of life.

The surroundings

I remember everything. I remember absolutely everything. History, my
dear listener, will prove that memory is the hideous curse of the haunted.
– Donald Rodney[87]

On the first page of one of Rodney's sketchbooks from 1997, underlined
twice is a note to self: 'AVATAR? (Find out the meaning of the word, is it re-
ally to do with Voodoo)'.[88] In investigating further, Rodney would have no
doubt read of the word's Western co-option from its origins in Sanskrit,
meaning 'descent', and in Hinduism, signifying the incarnation of a deity on
earth. Perhaps he would have connected this notion with the *loa*, who serve
as worldly intermediaries for Bondye, the supreme god of Vodou; and the
similar *orichas* (whose diverse material manifestations are sometimes called
avatars, or *caminos*) of Yoruba belief systems syncretised with Catholic the-
ology in the Cuban religion of Santería and in Afro-Brazilian religious tradi-
tions such as Candomblé. In the sphere of computing and virtual reality, the
avatar is something of an inversion of these concepts, a dematerialised ren-
dering of a material body. Perhaps more in keeping with the Sanskrit mean-
ing, the intent behind *Autoicon* is to generate an avatar that carries forward
the corporeal in the form of medical imaging and traces of Rodney's body,
augmented with the presence of his memories and accrued experiences,
behaviours and perceptions. Together, these elements suggest an aspiration
towards a form of artefactual embodiment, a mnemonic recovery of a pres-
ence in the face of an absence.

 The role of memory, and with it the writing of history (and the privileged
subject of history), formed contested critical and artistic terrain in the late
1980s and into the 90s, against the backdrop of the 'weakening of historicity'
as a perceived keystone of the postmodern condition.[89] Within the politics of
representation and the struggle for recognition of cultural difference, Lisa
Lowe characterises culture as both 'the medium of the *present*', that is, 'the
imagined equivalences and identifications through which the individual in-
vents lived relationship with the national collective', and simultaneously 'the
site that mediates *the past*, through which history is grasped as difference,
as fragments, as shocks, and flashes of disjunction'.[90] For Rodney, as part
of a generation of young black people growing up in the UK with parents

who immigrated from the Caribbean following the Second World War, cultural life from church to reggae music was thick with the voicing, as Eddie Chambers has identified, of 'the experience of exile, diaspora, home and belonging ... righteousness, salvation and redemption – spiritual, cultural and political'.[91] In *The Black Atlantic: Modernity and Double Consciousness* (1993), Paul Gilroy sees such narratives of 'loss, exile and journeying' as serving a mnemonic function: 'directing the consciousness of the group back to significant, nodal points in its common history and social memory'.[92] In the face of mainstream racist mediations of social crisis in Britain – in which a representational dehumanisation complemented a political-economic lineage running from slavery, through imperialism, to the exploitation of an immigrant workforce in the post-War period – this work of memory took on various critical forms, with differing valences given to the restitution of a unified ancestral past and the inauguration of potential futures.

As a work enacted in the event of the artist's death, *Autoicon* could be misapprehended as a memorial, a commemorative object. But this would be to negate Rodney's conception of the work and its relations with his wider practice; it would also neglect the fact that in its realised form *Autoicon* is not a neatly packaged archiving of memory, a narrative of a life, or a coherent representation of a historical personality. Rather, it is grounded in an approach to form that emphasises fabulation, fissures, non sequitur and, in the parlance of digital technology, 'lossiness'. The 'montage' function, in particular, embraces error and randomness by visually transposing interactions with *Autoicon* into constant informational assembly and dis-assembly. While characteristic of the encoding and decoding of digital information, this formal approach also invokes the slipperiness of signification that demarcated postmodern culture in the 1980s and 90s. Like other black British artists and cultural theorists of this period, in his work Rodney critically engaged the spectres of modernity and postmodernity through aesthetic and philosophical dimensions of diasporic understandings of history, narrative, place and futurity. As part of such lineage, *Autoicon* should be seen in antagonism with dominant forms of commemoration, as a forthright reckoning with a logic of historicity and memorialisation that operates through 'structured forgetfulness'.[93] The work activates sites of personal, collective and cultural memory where what has passed before is mediated not through direct recall, but by imaginative investment and creation in the present and future. As an

avatar, *Autoicon* sits in relation to Rodney's invocation of the ceremony of Nine Night in the exhibition '9 Night in Eldorado'. A gathering practiced in Jamaica and amongst the Caribbean diaspora at the death of a family member, Nine Night performatively marks and ensures – through celebratory remembrance, song, biblical texts, the making of food and domino playing – the moment of departure of a spirit from the physical world. Echoing the roots of this practice in acts of resistance against the violent displacements of the transatlantic slave trade, *Autoicon* is engaged in reconstruction in its double sense, what Toni Morrison called the exploration of 'two worlds – the actual and the possible'.[94]

'A Postmodern Postmortem'

First presented at Chisenhale Gallery in London and then at Graves Gallery in Sheffield, Donald Rodney's 1989 solo exhibition 'Crisis' featured multimedia works that made extensive use of X-ray plates arranged in grids or cut into silhouettes.[95] The periods Rodney had spent in hospital because of his sickle cell anaemia gave him access to used plates otherwise destined to be destroyed, along with X-ray images of his own body. Used en masse, the plates appeared as large-scale fragmented grounds over which Rodney applied oil pastel and paint to render figurative scenes, stencilled text and glyphs. Authored by Rodney, the Graves Gallery press release identifies the exhibition title as referencing the political crisis wrought by a decade of Thatcherism and the diminishing gains of the Left; the ever-worsening global ecological crisis; and the term used to describe a sickle cell attack. It goes on to state:

> *Sickle Cell affects only black and some mediterranean people. Within the society blacks are perceived widely as the disease within the body politic of Britain. The illness metaphor is the key to decode the visuals. The titles should be taken as a running commentary on real events within recent history.*[96]

While one of the works in 'Crisis' has since become known simply as *Britannia Hospital 3* (1988, fig. 17), Rodney's sketchbooks from the time indicate a longer title: *Emergency Casualty Ward. Britannia Hospital. X-ray Vision. Cherry Groce receives morphine for her spinal injuries. Broken*

Column. Stephen Bogle receives Pethadine for his sickle cell crisis. Injuries acquired whilst helping with 'police inquiries'. An officer stands guard. Directly appropriating Frida Kahlo's 1944 self-portrait *The Broken Column*, Rodney's *Britannia Hospital 3* shows, towards its left edge, the figure of a woman drawn in oil pastel, her body strapped with white belts and her chest opened to reveal a fractured ionic column in place of a spine. In this iconic image, he replaced Kahlo's head with a depiction of Cherry Groce, a black woman shot in her Brixton home in in 1985 by London's Metropolitan Police, and paralysed for life by a bullet lodged in her spine. On Groce's right stands a white member of the Met Special Patrol Group wearing a helmet and carrying a riot shield, his eyes devoid of pupils. A notorious unit of the British police charged with addressing 'public disorder', the SPG were responsible for the execution of racist stop and search laws in the 1980s, and they played a significant role in the provocation of and violent response to uprisings in Brixton in 1981 and following Groce's shooting in 1985. Partially obscuring the police officer's lower half is Rodney's rendering of a black man in a hospital bed, being tended to by a nurse. The scene is drawn with the foreshortened perspective of the view from the foot end of the bed – the man's hands are raised towards the viewer, flailing in seeming distress while the nurse reaches towards him. In 1986, Stephen Bogle died in police custody following his arrest while he was experiencing a sickle cell crisis. His condition was largely ignored during his time in the hospital wing of Brixton Prison, and he passed away after being forced to attend Thames Magistrates' Court, despite his visible ill health and inability to stand.[97]

Britannia Hospital 3 is exemplary of Rodney's references in 'Crisis' to news media images, the art historical canon and agents of the state – the police, security forces, the hospital and the judiciary.[98] The exhibition marks individual instances of violence and premature death perpetrated by the state on black people in Britain in the 1980s, as well as those committed under apartheid rule in South Africa, while locating these events within wider structures of physical, cultural and political evisceration. To a degree, the works in 'Crisis' took on the form of history painting – a register of events that, revisited a few years after their happening, are made manifest as both mnemic haunting and material trace. This sense of both cognitive and physical residue is concentrated in the accumulation of X-ray plates as the base of the works, suggesting a form of archival impulse: the forensic

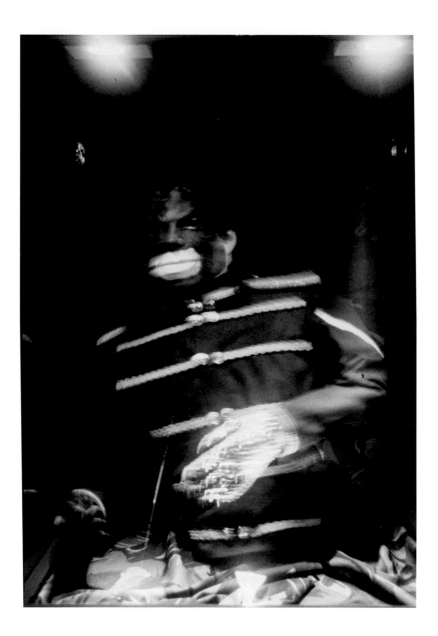

16. Donald Rodney, *Pygmalion*,
1997, mixed media. Courtesy the
Estate of Donald Rodney and South
London Gallery

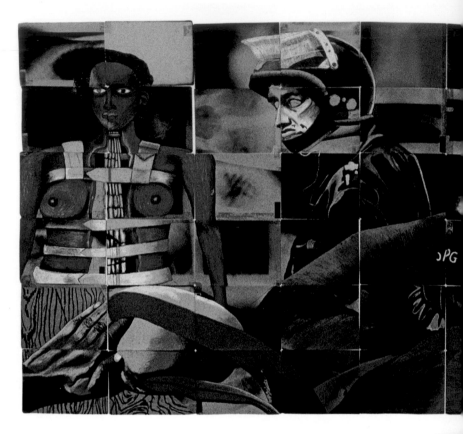

17. Donald Rodney, *Britannia Hospital 3*,
1988, oil pastel on X-ray, 83 x 447cm

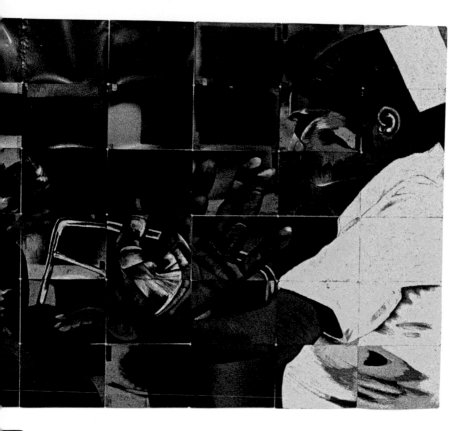

18. Donald Rodney, *Land of Milk and Honey II*, 1997, glass vitrine, copper coins, milk, 168 x 61 x 31cm. Digital image © Birmingham Museums Trust

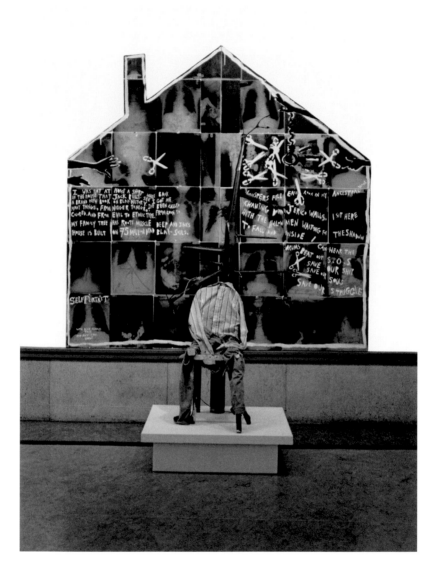

19. Donald Rodney, *The House that Jack Built*, 1987, mixed media, 244 x 244cm

20. Donald Rodney, *Flesh of My Flesh*,
1996, photographic triptych on
aluminium, 90 × 270cm

Above:
21. Donald Rodney, *My Mother, My Father, My Sister, My Brother*, 1997, skin, pins, perspex box, 3 x 2.5cm

Below:
22. Donald Rodney, *In the House of My Father*, 1996-97, photograph, 123 x 153cm

23. Donald Rodney, *Psalms*, 1997,
motorised wheelchair with proximity
detectors

mapping of body parts and injuries, traumas and tumours.[99] Making clear the metaphorical relation between the corporeal and the social, the Chisenhale Gallery press release states that Rodney 'turns Hobbes's analogy of disease as social disorder upon its head by suggesting that disorder and unrest are symptomatic of a sick society'.[100] Yet the materially diagnostic aspect of the X-ray resists a purely metaphorical reading, resonating with Ambalavaner Sivanandan's 1976 statement that British post-War appropriation of black labour, 'like a barium meal, reveals the whole organism of the state'.[101] A 1988 sketchbook entry by Rodney incisively states: 'X-rays as a visual feud between the politics of content and the content of politics.'[102] As bearers of existing material, informational and aesthetic qualities, the X-ray plates in 'Crisis' offered a portal through which Rodney critically approached the twin forces of cultural representation and scientific regulation as regimes with which acts of historical witnessing have to contend.

Another work included in the exhibition portrays a black man violently restrained by two police officers, and bears the title *Self-Portrait: Policing the Community, Death in the City: Mr Winston Rose, Mr Stephen Bogle and Mr Clinton McCurbin – A Postmodern Postmortem.*[103] The notion of a 'postmodern postmortem' is a wry commentary on a cultural periodisation in which, in Fredric Jameson's terms, 'the past as "referent" finds itself gradually bracketed, and then effaced altogether, leaving us with nothing but texts'.[104] The analytical frame of the postmortem – supported by the referential status of the X-ray – points towards the urgency of addressing the material effects of the 'real events' of history alongside their social construction, while also suggesting the need to interrogate the discourse of postmodernity as a Eurocentric conceptual framework. From the mid- to late 1980s, a series of vital scholarly publications and conferences addressed the position of black British identity and cultural production in relation to postmodernism. Writers and scholars particularly drew on the collective character of black artists' communities of production, presentation and distribution in the early 1980s, such as The Blk Art Group, of which Rodney was a member, and the film production workshops Ceddo Film and Video Workshop, Sankofa Film and Video Collective and Black Audio Film Collective, active in London. Many emphasised the correlation between the fragmentary character of the postmodern age and the migrant experience, with Stuart Hall observing, with respect to his own move from Jamaica to the UK in the early

1950s: 'Now that, in the postmodern age, you all feel so dispersed, I become centred.'[105] Hall articulated how the fictional nature of the modern self was recognised in the fragmentation of identities captured by postmodernist discourse; but equally, he argued that political action requires the 'fictional necessity' of moments of closure of identity around an imagined community. Within this dialectic space, Hall saw the possibility of a new conception of politics, identity and the process of 'becoming "selves"', which he later defined in relation to the diasporic experience: 'identities which are constantly producing themselves anew through transformation and difference'.[106] Such an understanding of identity emerged in contradistinction to the 'absolutism' of a dominant philosophical and cultural embrace of the postmodern – a discourse seen less as a seismic rupture of an established order, and more, in Paul Gilroy's words, as revealing how 'the grand narrative of reason is not currently being brought to an end but rather *transformed*'.[107]

In a foundational essay published in 1988, Gilroy applies the term 'populist modernism' to a global perspective adopted by earlier generations of black intellectuals and artists, evidenced in 'communicative networks produced across the Atlantic triangle' and now visible in 'elements' of a black British art movement.[108] This 'populist' tradition was connected to a vernacular one that embraced underground 'kaleidoscopic formations of "trans-racial" cultural syncretism'. As a counterpoint to postmodernism, Gilroy emphasises certain aesthetic and philosophical aspects of these traditions and their inquiries into the politics of representation. In particular, he cites the importance of an understanding of '"racial" memory' in 'affective and normative terms, rather than as a problem of cognition'. In diasporic creative works, he identifies the centrality of performance over text, and the 'intertextual patterns' between discrete texts and performances; the subversion of discipline and genre, 'evident in the autopoiesis of the slave autobiography ... and [its transcendence of] key Western categories: narrative and documentary; history and literature; ethics and politics; word and sound'; and the recognition of the inadequacy of language in general, as evidenced by the 'polysemic richness of black languages'.[109] While Gilroy locates the apotheosis of 'populist modernism' in black music's performative emphasis on expression over artefact, and he is critical of the material dependencies of black visual arts and film, his principles resonated in the practices of many of his artist contemporaries around the time of the essay's publication, in-

cluding Rodney, particularly in their application of strategies of hybridity and the formal use of collage, montage and bricolage.[110]

Gilroy's positioning of these diasporic vernacular traditions in distinction to postmodernist methodologies of appropriation and stylistic cannibalisation is echoed in a text published in the same year by Lubaina Himid, titled 'Fragments: An Exploration of Everyday Black Creativity and Its Relationship to Political Change'. Through a depiction of the communal practice of quilting undertaken by women in Soweto, South Africa, Himid asserts a notion of 'gathering and re-using' that is based not on disassociation or mimicry, but on 'real links' and the time taken to create stronger ones. Born from economic circumstance, these links 'between useful and useable objects of the immediate past and today and tomorrow' provide potential tools of political change. In Himid's description:

> A quilt made from gathered pieces of cloth takes time to plan, design and make. Often several women have worked on one quilt. It can be made as a testimony to time spent as well as lives lived. It is made to go into the future as a used object for a 'family' member, as a talisman for the years ahead and reminder of women past.[111]

This vivid articulation of the material fragments of multiple histories forming a new whole resonates with the methodology of collage employed in Rodney's works in 'Crisis'.[112] His use of X-ray plates brought into play the dense layers of indexical and metaphorical meaning that they carried as found material – a form of 'gathering and re-using' that prefigures the more radical development of *Autoicon*'s open-ended aggregation and composition of images through fragmentary processes of cut-up, montage and tiling. As with the pieces of cloth in a quilt, an individual X-ray carries distinctive, although opaque, personal histories – the temporal accretion of bodily markers of 'lives lived'. Yet time is also an operative factor of their utility to biomedicine in forming diagnoses and prognoses that seek to command both present and future conditions, while largely dispelling the past events that led to a patient's state of health.

Projection radiography is a peculiar form of hypomnemata – a technical tool for the exteriorisation of memory.[113] It is a means of 'seeing' that which is invisible to the human eye, and a simultaneous transference of this optic

into durable and repeatable form. In its aesthetic vagaries, its graduations from white to grey to black, it also amplifies a sense of the limits of scientific knowledge when faced with the body as a living memory of affectability. Rodney's gathering and re-use of X-ray plates made up a critical address of how living memory in all its forms – cerebral, muscular, linguistic, biogenetic – is exteriorised in technical 'dead' objects and institutions.[114] The presence of the plates in Rodney's work was constituted by his interactions with hospital environments; by the social symbolism of multiple bodies receiving medical assessment; and by the economic conditions that led to the availability of used plates (one review of 'Crisis' reported that Rodney purchased X-rays for '£1 per kilo from hard-up hospitals'[115]). As bodily and technical organs and social organisations coalesced in Rodney's methodological and formal approach, his use of X-ray plates in 'Crisis' prefigured a scenario that was to culminate in *Autoicon*'s digital form, in which 'living' memory and 'dead' memory 'compose without end'.[116]

Rodney's images in 'Crisis' mark and re-encode as personal narratives mediatised moments of deep trauma for black people in the UK and South Africa, drawing points of connection within the global structures of racialisation and the depths of past and present counter-struggles. If, as Rodney wrote, '[t]he illness metaphor is the key to decode the visuals', then 'illness', in 'Crisis', acted as a disruptor of prevailing codes, such as those entangled in the X-ray. In a 1989 sketchbook, Rodney noted a phone conversation with Himid in which she responded to the works in 'Crisis' by saying that 'the images of black as victim is confusing, only you could have done it. ... Being so close to hospitals and illness you, I guess, would understand powerlessness and scrutiny.'[117] Himid's reference to Rodney's closeness to 'hospitals and illness' indicates the irreducible complexity of the individual experience of pain and sickness – 'a' body, 'a' subject, under what Rodney terms 'constant control pressured and pushed within a tight margin of political control'.[118] In resistance to a white gaze that requires black suffering to perceive black humanity, Himid's 'Fragments' proposes the quilt as an example of 'a testimony to time spent as well as lives lived' – an emphasis not on a series of clarifications and exposures of selves, but a multi-accentual weaving of opacities. Rodney's work equally presents an unavoidable tension between testimony and opacity, between the documentation of episodes of bodily harm and killing perpetrated by the state, the indexical excess of X-ray plates and the per-

sonal experience of illness and medical scrutiny. In his sketchbook, Rodney underlined and repeated Himid's phrase 'only you could have done it', suggesting the importance of a personal, textural understanding of a system seen from a position of imposed vulnerability and dependence.

Spaces of memory and departure

What if there were a radical politics of innovation whose condition of possibility is memory, which remains untranslated, whose resistance, in turn, makes innovation possible? Not to resuscitate! No resurrection. Make it new, like they used to say, so that indexicality is an effect, a technique, so that recording is part of an experimental impulse. The archive is an assemblage. The assemblage is an image of disaster.
– Fred Moten[119]

Two particular spaces were prominent in the last years of Donald Rodney's life, conceptually and materially constituting the ground for the exhibition '9 Night in Eldorado' in 1997, and ultimately for *Autoicon*. Hospitalised for increasingly lengthy periods on public wards, Rodney gathered around him the materials and people to enable his practice and social life to continue. His friends who visited him regularly have testified that the area around his hospital bed was a space of humour, ideas, materials and production that belied the 'correct' behaviour of an institutionalised patient. Rodney's own Super 8 footage, some of which was posthumously included in John Akomfrah's 2008 film *The Genome Chronicles*, validates this testimony, documenting a scenography of nurses, doctors, friends, hospital equipment and procedures, and acts of care and laughter (fig.26). During one such period of hospitalisation in 1995, Rodney's father, Harold Rodney, passed away. While Rodney managed to attend the funeral, he was unable to be present for the Nine Night gathering of family members and friends that followed. The controlled bounds of the hospital supplanted the space of healing and conviviality of the Nine Night, a rite rooted in the family home but also in a spiritual movement between worlds. Deeply affected by having missed the ceremony that marked the 'discharging' of his father's spirit, the exhibition '9 Night in Eldorado' became for Rodney a parallel space of memory, collective care and gathering, as its realisation relied by necessity on extended collabora-

tion and assistance. The exhibition title references his father's favourite film, Howard Hawks's 1966 western *El Dorado*, and by extension Edgar Allan Poe's 1849 poem of the same name.[120] As a motif for Harold Rodney's life and his move with his wife, Iris, to England in the late 1950s, the double-edged allegory suggests a journey whose promise is never fulfilled and is ultimately marked by the limits of finitude. Alongside this diasporic journey, the passage encompassed by Nine Night – where on the ninth night after a person's death their spirit, the *duppy*, leaves the family home – forms a cosmology of memory, translocation, presence and absence that underpinned '9 Night in Eldorado'.

The Afro-Caribbean funeral rites from which Nine Night descends played a crucial role in what Sylvia Wynter documents and articulates as the 'periodic uprisings and ... ongoing creation of culture' that countered four hundred years of transatlantic slavery and Caribbean plantation society. In her unpublished monograph *Black Metamorphosis* (c.1971–81), Wynter speaks of 'marronages, mutinies, funerals, carnivals, dramas, visual arts, fictions, poems, fights, dances, music-making and -listening, revolts', as the means by which enslaved African peoples 'refus[ed] to accept [their] status as merchandise, [and] never ceased to reinvent [themselves] as human and to recognize [themselves] as such through [their] reinvention of the gods'.[121] Central to this reinvention were 'mourning rites ... which bring the present face to face with the past as the corpse is transmuted out of his temporary status to achieve a "permanent future" as an ancestor'. In relation to the often violently suppressed nature of material revolt under slavery, the funeral rites of enslaved communities constituted a form of limitless spirituality. Wynter describes a powerful entanglement of the material and the metaphorical:

> *Africa for the new exile was no longer a physical place – rather it was invested with all the power of a metaphor. It was a metaphor which enabled them to transcend their brute and present reality. Africa was now the realm of transcendence. Later a dream of 'Heaven' would help them to survive reality. The form of the metaphor would change but never the content. ... Heaven or Africa, Zion or the New Day, home was where the hope was. Hell and exile were here and now. Inherent in all this was a powerful metaphorical critique of the status quo.[122]*

Writing at the height of independence movements in the British Caribbean in the 1960s and 1970s, Wynter vitally asserted the continuity of critique across the diverse religious and spiritual convictions held in the region. Similarly, in his novels and sociological analysis, Orlando Patterson has rendered the complex nature of intertwined real and false hope offered by religious movements such as Rastafari and Revivalism in newly independent Jamaica, foregrounding the cultural and psychic continuities between the 'natal alienation' of historical slavery, the spiritual survival strategies of the enslaved, and the social alienation experienced under colonialism and neocolonialism.[123]

Harold and Iris Rodney were members of a predominantly black Pentecostal Church that they helped set up in Smethwick, a town in the West Midlands of England, where Donald Rodney grew up. While the Pentecostal movement came to the Caribbean from the United States in the early twentieth century, the focus in its services on song, dance and spiritual possession (including 'speaking in tongues') took on aspects of a wider Revival movement that emerged in late-nineteenth-century Jamaica through a syncretism of Obeah/Myal African beliefs with Christian orthodoxy. In a 1994 interview, Rodney described how the Jamaican church 'seemed to have metamorphosed from something that was supposed to be Christian into something totally different and made in our own image'.[124] He developed a complex relationship to the church through its centrality to his parents' lives, and it became its own ground for metaphorical critique in his work. Employed in textual and artefactual forms, the language and liturgy of the church, its resonance with narratives of exile, belonging and ancestor-ship, stands in Rodney's work as a register of states of internal conflict: Christianity as both a dehumanising, paternalist and colonial force, *and* a space of diasporic imagining and black British-Caribbean identity; and in parallel, ancestral Africanity as both a pivot to unified black struggle and liberation, *and* a potentially essentialising false consciousness. Accordingly, the practice of Nine Night exists as a mutable cipher for a complex notion of cultural identity that, in Stuart Hall's words, is '"framed" by two axes or vectors, simultaneously operative: the vector of similarity and continuity; and the vector of difference and rupture'.[125]

Two works included in '9 Night in Eldorado', *Land of Milk and Honey I* and *II* (both 1997), particularly encapsulate the complexity of

Afrodiasporic becoming; they also resonate with *Autoicon*'s status as both a 'living' system and a transitional bearer of memory. Distinct from the representational character of earlier works that address the hopes and expectations of Rodney's parents on moving to England – such as the mixed-media assemblage *Voyage of My Father* (1985) and the painting *Pilgrim Father* (1986) – these works reconstitute existing materials into new biological and symbolic entanglements. *Land of Milk and Honey I* and *II* comprise rectangular sealed vitrines: the first oriented horizontally and placed on a plinth; the second, larger version standing vertically and taking on the statuesque scale of a minimalist monolith (fig.18). Each vitrine is filled with a combination of coins, milk and honey. The materials combine as a closed system of reactants, with the copper coins gradually corroding due to oxidation and the lactic acid produced by the milk's bacteria, giving a greenish hue to the liquid. While appearing as gestalt sculptural forms, *Land of Milk and Honey I* and *II* are durational works without a defined end point. The static, framed views of each face of the vitrines are at odds with the ongoing chemical changes, which become apparent over time in slow alterations in the position and colouration of the coins and the surrounding liquid – a constantly evolving copper and milky-green pointillism.[126] A number of black-and-white photographs in Rodney's archive, taken by the artist Dave Lewis most likely in 1997, show preliminary tests for *Land of Milk and Honey,* with jars and bottles filled with milk, coins, hair and keys.[127] One image is titled *Memory Jar,* linking these vessels to objects also known as 'memory jugs' and placed on graves in African American communities in the American South, a practice thought to have been carried forward from Kongo funereal practices in Central Africa.[128] These jugs and other water-bearing containers are often covered in shards of china, keys, buttons, coins and other small objects belonging to or in memory of the deceased; the vessels play a role in remembrance, but also, through the belief in water as a conduit to the spirit world, in the safe passage of the deceased. In Rodney's versions, the objects are inverted, with items distilled into singular categories – coins, keys, hair; money, property, body – and placed inside the vessels, submerged and sealed, seemingly in liquid stasis. In their opacity and interiority, these filled 'memory jars' generate a sense of claustrophobia and containment, a horror vacui wherein the active mnemonic processes of the cultural fragment have been internalised and corrupted.[129]

If *Land of Milk and Honey I* and *II* are to be read through the titular figure of the biblical quest for a promised land, the works metaphorically speak to the false expectations perpetuated by Britain when seeking a post-War migrant workforce from the so-called Commonwealth – a vision of hope soured by corrosive economic imperatives. Under the sign of the diasporic journey, the extended temporality of these works evokes the *longue durée* of racial capitalism – the forced transmutation of human beings into fungible objects, their translocation and binding into metabolisms of extraction and exhaustion. While monetary capital exists quite literally in abrasive relation to its surroundings in the *Land of Milk and Honey* works, the view into an interior space of biochemical reaction also implicates the affected body. For Rodney, the body was a site of specific sociogenic conditions transmitted across generations and locations in the form of sickle cell trait. The necrosis that accompanies sickle cell anaemia, known as infarction – a death of bodily tissue in the joints caused by constricted blood supply – is an extended process of cellular breakdown that can be seen as mirrored in the slow dissolution of copper coins. *Land of Milk and Honey I* and *II* quiver between monument to diasporic life and autopathography of accumulated molecular affects.

Digital diaspora

In 1997, Donald Rodney received Arts Council funding for multimedia training under the scheme 'Digital Arts & Disabled People', organised through Iniva and the Arts Technology Centre (Artec). The training marked a necessary shift in Rodney's artistic production, his increasing physical immobility and periods of hospitalisation having already been a factor in his earlier departure from painting into photography and installation. These practical considerations perhaps occlude an interest in contemporary media that spanned Rodney's working life – from film, TV reportage and computer games to his compulsive collecting of newspaper clippings. In the period prior to his death, Rodney developed ideas for digital works that overlapped with and ultimately merged into *Autoicon*, including the CD-ROM-based work *Wound* (featured in the 1996 exhibition 'The Visible and the Invisible: Re-Presenting the Body in Contemporary Art and Society' at the Wellcome Centre for Medical Science in London) and an unrealised work that aspired to use computer game technology alongside the genre of the role-play adven-

ture to 'explore some of the diverse issues that cocoon the black body'. In his sketchbook, Rodney noted: 'Using the literary tradition of the traveller or stranger in a strange land the CD Rom would examine Dis-ease, Disease, the Black Diaspora and the polymorphic territories [in which] myth stereotype difference and desire dwell.'[130] The narrative vehicle of the 'traveller ... in a strange land' – resonating with the mythical figure of El Dorado, the land of milk and honey – is itself analogous to the horizons of user experience proposed by nascent conceptions of virtual reality and the 'metaverse' in the 1990s.[131] The very terms under which such 'travel' was engaged often veered towards frontiersmanship and the hyperbolic. Roy Ascott, a prophetic figure in the field of computer art and telematics in Britain since the 1960s, has likened the 'double consciousness' enabled by digital technology to taking ayahuasca as part of a shamanic ritual: '[I]n our artistic aspirations in cyberspace ... our bio-telematic art, we are weaving what I would call a shamantic web, combining the sense of shamanic and semantic, the navigation of consciousness and the construction of meaning.'[132] In contrast, Rodney's intent to examine 'the polymorphic territories' of myth, stereotype, difference and desire implicates an already conflicted space of becoming and ontological insecurity.

The lineage of networked art is largely historicised as tied to the politics of dematerialisation around conceptual and cybernetic art of the 1960s and 70s, with an emphasis on information and its circulation as an act of freeing art from its commodity status. Yet, it is also indelibly linked to the military and corporate development of computational and telecommunications technologies. At the point of the inception of the World Wide Web in 1990, and its development as a widely used protocol with the release of the Web browsers Netscape and Internet Explorer in 1993 and 1994, a future of corporatised hegemony of information technologies became increasingly apparent to those used to the relatively open sphere of bulletin board systems. In this period, a burgeoning of multimedia and net art practices that attempted to rupture or re-deploy emergent online territorial structures was paralleled by the formation of institutions, workspaces and research facilities that varyingly enabled and implicated such practices within wider agendas. In the UK, these initiatives included Backspace in London, a media lab that was run by the commercial design company Obselete and provided subscription-based access to computer terminals and Web and server space, and Artec, funded

by the European Commission and established in 1990 as the country's first centre dedicated to the creative application of digital technology. In the academic arena, the mid-1990s saw the formation of Roy Ascott's Centre for Advanced Inquiry in the Interactive Arts (CAiiA) at the University of Wales, Newport, and Science Technology Arts Research (STAR) at University of Plymouth, which Mike Phillips played a significant role in establishing.

In this context, Rodney's *Autoicon* emerged out of a distinctive set of conceptual and organisational formations that carried forward the late-1980s discourse around the diasporic into the sphere of the digital. These formations specifically marked out the shifting ground of technological image production – from photography to moving-image and digital media – as possible sites of counter-modernity and intertextuality. Keith Piper and Gary Stewart, future members of Donald Rodney plc, were central to these developments. Stewart studied electronics and computing at Trent Polytechnic during the same period in the early 1980s when Piper and Rodney attended the college, and in 1991 he became multimedia producer at Artec. Around this time, Stewart became involved in the production of a CD-ROM version of *Ten.8* magazine's seminal 1992 issue, 'Critical Decade: Black British Photography in the 1980s', which featured the writing of scholars such as Stuart Hall, Paul Gilroy and Kobena Mercer, alongside photography-based projects by close to fifty artists, including Piper, Lewis and Chambers.[133] Through this project, Stewart began a dialogue with the writer and curator Gilane Tawadros, another contributor. A key figure in the development of an 'institute of new international visual arts' in London, Tawadros became the first director of the officially named Institute of International Visual Arts in 1994. With Hall as the chair of its board, Iniva built on the rigorous institutional criticism forged over the previous decade by black British artists, curators and scholars to address the significant absence of black voices within UK galleries and museums.[134] Resisting, however, a path of bricks-and-mortar institutionalism, Tawadros's innovative directorship conceived of Iniva as 'a sort of production company that will work with institutions or individuals to produce exhibitions, publications, seminars, research projects and build up a library and archive'.[135] In line with this vision, in 1995 she recruited Stewart as head of multimedia, and he went on to develop and run the ground-breaking X-Space on Iniva's website. While X-Space presented itself as the online manifestation of Iniva's agenda, its main focus was on pro-

ducing and hosting a series of artist commissions for the Web that pushed the possibilities of the nascent form, drawing on Stewart's own expertise and contacts in multimedia production and programming.

The technological and programmatic framework of X-Space was, in turn, influenced by Piper's artistic practice, particularly his moving-image works and multimedia installations of the late 1980s and early 1990s, and his pioneering use of home computers such as the Commodore Amiga. In this period, Piper formed the collective Digital Diaspora, later Displaced Data, together with writer and researcher Janice Cheddie, artist Roshini Kempadoo and producer and co-founder of Artec Derek Richards.[136] Their 'idea of digital diaspora', as Cheddie articulated, was not 'the idea of the Internet or digital technology as returning or re-unifying peoples who live or experience diaspora'. Rather, the digital diaspora they had in mind 'takes as its starting point the making and re-making of critical ways of thinking about one's place in the world as a series of multiple and complex starting points'.[137] In their artwork and advocacy, the Digital Diaspora collective crucially resisted the prevalent universalising ideal of cyberspace, recognising instead how it continued to work within existing territorial frameworks of exclusion. For instance, Kempadoo's Internet-based work *Sweetness and Light* (1996, fig.31) presents montaged images of British landscapes, anthropological photography and computer hardware, alongside quotes from historical publications on plantation systems. As Kempadoo has explained:

> *It can be argued that it is politically essential to look at and analyse media networks/cyberspace in this way – looking at the structures, process and institutions. While this is necessary, however, it can never fully explain or make clear how power relations are embedded and sustained. ... [I]t doesn't fully explain the consistent stereotypical forms of representation emerging in the vast amount of information flow.*[138]

In 1997, Piper held the 'retrospective' solo exhibition 'Relocating the Remains' at the Royal College of Art in London. Initiated and produced by Iniva, the project also included a publication, a CD-ROM (fig.27) and an online 'studio'.[139] Rather than taking the conventional form of a survey exhibition – an approach that would have been impossible given that many of

Piper's early paintings, collages and installations had been lost, damaged or dismantled – the exhibition was comprised of three digital installations in which key elements of his works from 1982 to 1996 were reconfigured. In Tawadros's words, these installations presented 'a palimpsest of narratives; layer upon layer of images, sounds and texts which intersect and overlap'.[140] As discrete works, the online studio and CD-ROM built on the structure of the exhibition and furthered its interactivity. The user could navigate through three rooms of a museum-type space, categorised as three 'expeditions': UnMapped, UnRecorded and UnClassified. In each case, an image of a two-dimensional artwork became a navigable portal through which further images, animated icons, texts and links were accessed. Addressing the colonial mapping of bodies, the elision of histories and the surveilling and classifying of peoples, these 'expeditions' utilised the mutability of digital space to engage the user in discomforting processes of concealment and uncovering, scanning and targeting. Extending a long-standing engagement with the politics of mapping, Piper utilised the premise of an interactive archive to implicate the realms of computer programming and digital imaging both in the fixing of black bodies and identities, and in a possible counter-imaginary.

The CD-ROM and online studio of 'Relocating the Remains' were built using the previously mentioned software programme Macromedia Director, based on computer scientist John Henry Thompson's scripting language Lingo. Born in London in the late 1950s to Jamaican parents, Thompson built his career in the US, and developed Lingo in 1988. Stemming from Thompson's studies in both the visual arts and computing, Lingo is credited as enabling the use and manipulation of different image, video and animation formats in the building of interfaces and interactive platforms. Referring to the research of Henry Louis Gates Jr and Robert Williams on black speech, Piper has argued that Lingo's 'revolutionary development in computer scripting' is based on 'a radical adaptation of Black or Ebonic speech patterns in which words become objects, or containers of meaning which can shift in relationship to context ... and who may be listening'.[141] Such a mutable strategy of encoding is paralleled in Thompson's central innovation in Lingo for a 'variable to hold any value'. Due to its use of 'syntactic fragments' from two language systems – machine code and inter-human language – Piper has described Lingo as a form of 'CyberEbonics', a derivation of the patois and creole developed by people of African descent in the

West to permit the navigation of 'spaces dominated by the language systems of European colonisers'.[142] Echoing Paul Gilroy's description of the 'polysemic richness of black languages' and a diasporic emphasis on performance, 'Relocating the Remains' similarly suggested the need to reconstitute language and the production of space in order to 'unmap' the histories, physical bodies and memories inscribed within the frameworks of colonial and racial capitalism.[143]

The formation of Iniva's X-Space and the work of Digital Diaspora/ Displaced Data, and that of the group's individual members, particularly Piper's, collectively point to the critical socio-technological juncture at which *Autoicon* was conceived. The development and diffusion of 'home' digital devices, information processing tools and learning algorithms in the 1990s exacerbated the technological mediation and mapping of everyday life. The organising of data into discrete spatio-temporal classifications serves only to amplify the existing epistemic processes by which a racial imaginary becomes possible – a process that the notion of 'digital diaspora' troubles and subverts. The resistant digital environment that Piper articulates through the material dimensions enabled by Lingo reflects Wynter's framing of blackness in relation to 'tactics both of metamorphosis and of marronage (escape)'.[144] It is telling that in his notes Rodney imagined a computer game work placed at the intersection between narrative and the 'cocooning' of the black body. As a work of 'displaced data', in turn inspired by the ceremony of Nine Night in its aim to surpass corporeal, spatial and temporal bounds, *Autoicon* is invested in both narrative (re)invention through the navigation of memory fragments and media artefacts, and the resistance to states of physical capture reproduced by technology.

Object, memory, fabula

In his often-quoted study *The Language of New Media* (2001), Lev Manovich outlines two parts to the computer's ontology: the data structure, as 'collections of individual items, with every item possessing the same significance as any other'; and the algorithm, as 'a sequence of simple operations that a computer can execute to accomplish a given task'. While data structures and algorithms 'are equally important for a program to work', Manovich sees these ontological parts as corresponding to distinct cultural forms of the computer age: 'CD-ROMs, Web sites and other new media objects organized

as databases correspond to the data structure, whereas narratives, including computer games, correspond to algorithm'. The database form, mirroring real-world collections such as libraries, archives and museums, privileges the goal of information access, while the narrative form – clearly aping the cinematic in the navigable 3D space of computer games – centres 'psychological engagement with an imaginary world'. In the sphere of computer culture, for Manovich, the database form supersedes that of the narrative to the extent that all new media objects 'can be understood as the construction of an interface to a database'.[145] The database is the foundation, and the user – whether interacting with a website search tool or a computer game – is called to engage with and consciously 'perform' the algorithm by which the data is accessed. For Manovich, database and narrative are 'natural enemies' – the representation of the world as an unordered list versus a 'cause-and-effect trajectory of seemingly unordered items (events)'. Ten years after his study, N. Katherine Hayles reframed this relationship as that of 'natural symbionts'. In her articulation: 'If narrative often dissolves into database ... database catalyzes and indeed demands narrative's reappearance as soon as meaning and interpretation are required.' In the face of the exponential increase of information and data brought about by the Internet, the form of the database has an advantage over narrative in that new elements can be added to existing databases without disrupting any ordered trajectory. But for Hayles:

> The flip side of narrative's inability to tell the story is the proliferation of narratives as they transform to accommodate new data and mutate to probe what lies beyond the exponentially expanding infosphere. No longer singular, narratives remain the necessary others to database's ontology, the perspectives that invest the formal logic of database operations with human meanings and gesture toward the unknown hovering beyond the brink of what can be classified and enumerated.[146]

Manovich's assertion of the centrality of 'database logic' to the CD-ROMs and websites of the 1990s is borne out by the structure of *Autoicon*. The collection of biographical and artistic materials selected by Donald Rodney plc form its unordered database. In the work's Web form, this database has an

expansive aspect through an additional set of hyperlinks to other websites, and, within its 'montage' function, it facilitates an open crawl of the Internet for additional image content. However, *Autoicon* is clearly not a straight-forward information access programme. Its interface encourages a user to 'chat' rather than issuing the (now ubiquitous) prompt to 'search', and the content of this chat forms part of a recursive learning process that influences future outputs. The user 'interacts' with the 'autoicon' of the artist Donald Rodney, a premise that is at once an articulation of accumulated data – the collated multimedia index of a life and artistic practice – and a 'gesture toward the unknown hovering beyond the brink of what can be classified and enumerated'. The 'chatbot' prefigures the proliferation of messaging tools and their linear representation of dialogical back-and-forth. Yet the visual palimpsest of pop-up windows – each appearing in random locations on the interface – and the separate, ever-building 'memory' of keywords, which capaciously relate to individual files and influence *Autoicon*'s behaviour, generate a superfluity of connections and possible interpretations that cannot be abstracted from their particular performative instantiation. *Autoicon*'s algorithmic logic is one of legible pattern and randomness, coupled with a cumulative opacity of textual interplay through an excess of image, sound, text and movement.

If, in Manovich's terms, 'an interactive narrative can be understood as the sum of multiple trajectories through a database', what kind of narrative is offered up in the trajectories followed by the user of *Autoicon* – which stem both from the confabulatory arrangements made by Donald Rodney plc and the potentially infinite pathways and contexts generated by the Internet and other users' interactions?[147] When addressing the question of narrative, both Manovich and Hayles directly reference Mieke Bal's conception of narratology. Bal's theory is constituted by three layered definitions:

> A narrative text *is a text in which an agent or subject conveys to an addressee … a story in a medium, such as language, imagery, sound, buildings, or a combination thereof. A* story *is the content of that text and produces a particular manifestation, inflection, and 'colouring' of a fabula. A* fabula *is a series of logically and chronologically related events that are caused or experienced by actors.*[148]

If conceived of as such a narrative text, *Autoicon* certainly enables users to come away with a partial chronological understanding of Rodney's 'story'.

Yet, at the core of the aggregative act of 'traversing' *Autoicon*'s database lies a resistance to the hierarchical structure of narrative, story and fabula. As Rodney's voice, words and image repeat and accumulate on-screen, alongside other actors' reflections and reference points, what dominates is a multiplication of recalled events and their inflection, without focalisation; that is, without the single perspective through which a narrative is presented. By design, the user plays a central role in guiding the direction of the 'chat', and therefore what material is accessed, perhaps seeking to decipher the underlying algorithm and reveal fresh 'data'. The programme, however, does not conform to a readily legible keyword logic – for instance, even if a user repeats a question or statement word for word, the 'answer' from *Autoicon* will not necessarily be the same. The 'fabula' of Rodney's biography and artistic practice is ever present, if always partial and fragmented; yet its 'colouring' is dispersed and unbounded. In an early meeting of Donald Rodney plc, the group wrestled with the responsibility of (re)constructing a distinct persona through 'anecdotes and our knowledge of Donald', and the fictionalising nature of this process. Reflecting on the possibility of a future *Autoicon* user quoting from the work as if it were Rodney's words, Piper asks: 'Who would know that that's where the quote or the idea or the notion came from? If you ask a question and it comes up with an answer that seems to make sense but isn't what he really would have said?' In response, Phillips points to the nature of artistic subjectivity as already circumscribed by performativity and external influence: 'But isn't that a bit like interviewers saying it's not really Donald its [*sic*] Donald performing? If it's mixing anecdote with factual statements, with memories, with things off the web, then it begs questions about what one would go and talk about with an artist anyway.'[149]

Autoicon's resistance to the focalisation of imposed narrative finds resonance in Bal's understanding of memory. While memories are often considered as narrative acts – where 'loose elements come to cohere into a story, so that they can be remembered and eventually told' – in relation to the fabula (the events as they happened), they are notoriously unreliable and often 'rhetorically overworked'. Bal refers to the gaps and lacunae that occur within memories of traumatic events, locating the 'incapability' of remembering at the level of both story and text. But she also highlights the function

of memory as the 'joint' between time and space, citing the example of stories set in former colonies, in which 'memory evokes a past in which people were dislodged from their space by colonizers who occupied it, but also a past in which they did not yield'. The act of looking backwards, 'providing a landscape with a history', becomes 'a way of countering the effects of colonizing acts of focalization' engaged in processes of mapping – '[m]astering, looking from above, dividing up and controlling [as] an approach to space that ignores time as well as the density of its lived-in quality'.[150] In a contemporary era dominated by screens, such mapping processes migrate back and forth between the virtual and the material. Endowed with 'Rodney's memories and experiences, fleeting images of the past', *Autoicon* posits an alternative, antagonistic approach to the spatio-temporal condition of the screen, one that privileges the 'density of [the] lived-in' over the database or the focalised narrative text.

Alongside works such as Kempadoo's *Sweetness and Light* and Piper's *Relocating the Remains*, *Autoicon*'s space of memory, partly technologically 'programmed' and partly fabulatory, has deep resonances with two other crucial works of net and new media art produced in the late 1990s. The intertwining of memory with the body, in conjunction with the politics of narrating, is taken up in Graham Harwood's 1996 interactive CD-ROM *Rehearsal of Memory* (fig.28). Harwood worked in the education department of Artec in the mid-1990s, and, under the auspices of its new media training programme, co-founded the artist collective Mongrel. Begun as an installation-based project in 1995, *Rehearsal of Memory* pre-empted the community-oriented focus of Mongrel's work and developed in collaboration with a group of incarcerated men at Ashworth Hospital, a high-security facility near Liverpool. The resulting CD-ROM is a visceral and compelling collation of personal experiences accessible through an interface that mimics an invasive body scan. The participants all contributed xerographic scanned images of their bodies – their faces, scars and skin pressed against the scanner plate in high-contrast exposure, which were then spliced together to form composite bodies. The user of *Rehearsal of Memory* navigates across this collective corpus of extreme close-ups, encountering tattoo-style text and drawings on skin alongside objects – bottles of pills, keys and books – floating in negative space. Clicking on these elements generates subtle changes to a background drone of voices and environmental noise. Snippets of the par-

ticipants' testimonies slip through, telling of their lives inside and outside of prison, and their struggles with trauma and treatment. Harwood's synthesis of these personal accounts endeavours to lay bare the institutional targeting of bodies and psyches, while generating forms of archiving 'that act as a mirror to ourselves (i.e. "normal" society) and to our amnesia when confronted with society's excesses'.[151] While the form of the work resists a controlling external focalisation, its 'capture' of bodies that remain anonymous – conjuring analogies with medical dissection, microscopic analysis, surgical re-composition and branding of the skin – is discomforting in its doubling down on a highly psychopathologised scene of subjection.

If *Rehearsal of Memory* presents new media as a vehicle for bodily remembrance that resists societal 'amnesia' and disciplinary surveillance, another multimedia work produced around the same time, Shu Lea Cheang's *Brandon* (1998–99, fig.29–30), articulates the same prospect while functioning, like *Autoicon*, under the additional burden of posthumous memorialisation. The work centres on the life of Brandon Teena, a trans man who was raped and murdered in Nebraska in 1993. Teena was the subject of a film documentary in 1998 and an acclaimed narrative biopic, *Boys Don't Cry*, the following year. In contrast to these portrayals, *Brandon* is a multifaceted and multi-authored approach to Teena's story, coalescing around a website and a year-long programme of formal and informal events taking place on and offline.[152] As it exists today, *Brandon* provides a portal to this 'social and academic space' through audio recordings, chat room transcriptions, essays and literary texts located within five navigable interfaces: 'bigdoll', 'roadtrip', 'mooplay', 'panopticon' and 'Theatrum Anatomicum'. While the contemporaneous filmic representations of Teena constructed versions of his life and horrific death as moralist conundrums, Cheang's positioning of Teena in cyberspace serves to interrogate the potential of the Internet as a space of gender and character play, simultaneously under the threat of biotechnical and biopolitical control. As with *Rehearsal of Memory*, the skin – present in images of piercings, bare bodies and surgery – becomes an analogy for the communicative tissue of media, and a malleable meeting point of interior and exterior, the biological and the figurative. *Brandon* is a rich, complex and often graphic experience for the user as it renders visual and textual effects in real time. Moving through different genres of narration – the cinematic, the cut-up and the conversational – and mediating between forms

of artistic experiment, speculative thought and juridical process, Brandon's multiple interfaces evidence the many authors involved. The work exists as a communal memorialisation of Brandon Teena: not an attempt to know and inscribe his identity in history, but a collective deconstruction in the virtual realm of the complex possibilities and harms held by the social, political and corporeal conditions that impacted on him.

At a surface level, these works by Harwood and Cheang, along with Piper's *Relocating the Remains* and Rodney's *Autoicon*, can be seen as representative of a broader dissent towards a utopian vision of cyberspace in the 1990s. Such antagonism was informed by influential critical theory of the previous three decades on informatics and control, from Michel Foucault and Gilles Deleuze to Jean Baudrullard and Donna J. Haraway. At a more particular level, however, the resonances between these works depend formally on the possibilities opened by programming languages and scripts such as Lingo, and on their critical address of narrative conventions through spatialised and multiplied perspectives, and user interactivity. What is evident in all of these works is not a proficiency of construction – the seamlessness of the algorithmic generation of 'psychological engagement with an imaginary world' – but an active and communal effort of storytelling held in opposition to institutional speculation and the organisation of data. Tellingly, these efforts of reconstitution pass through a close engagement with the skin, often depicted in tactile close-up. Frantz Fanon's *Black Skin, White Masks* (1952) addresses the consciousness of a person of colour in the 'white world' as underpinned by a 'racial epidermal schema'. Fanon understood his self as woven by the white man 'out of a thousand details, anecdotes and stories', making him 'responsible at the same time for my body, for my race, for my ancestors.'[153] *Autoicon* directly counters such a reduction of the variability of human life into details, anecdotes and stories – the taking over of the body by a host of stereotypes. Like *Brandon*, its rootedness in absence and loss conjures memory as a tensile force, caught between the desire to produce a representational presence in resistance to 'structured forgetting', and an intersectional awareness of the violent circumscription of the figure of the human. *Autoicon* stands as a space of sanctuary and possibility that embraces 'recording [as] part of an experimental impulse'[154] – an act of mobile assemblage at morphological, corporeal and narrative levels.

The interaction

MY INFUSION
MY ~~APPEARANCE~~ CHARACTERISTICS FACE
MY CHARACTERISTICS EYE
MY CHEST SYNDROME
MY INFARCTIONS HIP
MY INFARCTIONS SHOULDER

MY SICKLE CELL	*MY LOVES*
MY SHIP SAILS IN	*MY INJECTIONS*
MY SUGAR	*MY BLOOD*
MY RACE	*MY HEROS*

– Donald Rodney[155]

The CD-ROM version of *Autoicon* includes a 'View Slideshow' function in its 'Activities' drop-down menu. Originally put together by Mike Phillips and his colleague Geoff Cox for a talk about the work, the slideshow features a number of textual and visual references that locate *Autoicon's* conceptual framework between Michel Foucault's biopolitics and Donna Haraway's cyborg theory.[156] By the mid-1990s, Haraway's figure of the cyborg, outlined in her 1985 text 'A Cyborg Manifesto: Science, Technology and Socialist Feminism in the Late Twentieth Century', had become an influential trope of the hybrid human/machine. Haraway saw in the coding of both body and machine-as-information an opening towards a radical feminist posthumanism, dissolving the boundaries and categories of Western humanist philosophy. Her critical articulation of the cyborg emerged in parallel with developments in computational cognition that attended to the possibilities of artificial thinking independent of the human body. As N. Katherine Hayles highlights, such a desire to surpass corporeality relied on the assumption that 'information can circulate unchanged among different material substrates' – that consciousness, transferred from brain to machine, could exist without loss or alteration. In the giddy posthumanist embrace of disembodiment, the body is considered as a prosthesis that can be replaced with other prostheses, and the conception of 'human being' is configured in order to be 'seamlessly articulated with intelligent machines'.[157] The generation and manipulation of informational pattern takes precedence over and above embodied, fleshly presence and absence.

As Phillips and Cox's presentation attests, *Autoicon* was undoubtedly cyborgian in its intent, a form of 'serious play' against emergent structures of power. But in its entanglement with Rodney's experience of intensive medical interventions, and its production in the aftermath of his death, *Autoicon* also profoundly contests the manner in which the cyborg – as entity and metaphor – elides the material realities of forms of complex embodiment. As such, it resonates with recent scholarship that has challenged the promise Haraway saw in the transposition of 'bodies and works' into 'texts and surfaces' for largely erasing the lived experiences of the disabled and raced body.[158] As Therí Pickens states, the figures of neither the black nor the disabled cyborg 'can escape the desire for normalcy that erases Blackness and [disability] both'.[159] A frequently cited passage in 'A Cyborg Manifesto' asks:

> *Why should our bodies end at the skin, or include at best other beings encapsulated by skin? ... For us, in imagination and in other practice, machines can be prosthetic devices, intimate components, friendly selves. We don't need organic holism to give impermeable wholeness, the total woman and her feminist variants (mutants?).*

For the image of the body that does not 'end at the skin', Haraway takes inspiration from Anne McCaffrey's 1969 book *The Ship Who Sang* and its protagonist – 'a cyborg, hybrid of girl's brain and complex machinery, formed after the birth of a severely handicapped child'.[160] Alison Kafer has questioned this reliance on the stereotyped expectation that physically disabled bodies are totally dependent and therefore in need of a 'technological fix'. Such a reduction of disabled people to the status of 'exemplary hybrids', enabled and made whole through technological prosthesis, both perpetuates a logic of abnormality and overlooks questions of what such hybridization feels like and entails. Working within the realm of crip theory and politics, Kafer calls for a comprehension of 'disabled people as cyborgs not because of our *bodies* (e.g. our use of prosthetics, ventilators, or attendants), but because of our *political practices*'. The political promise of permeability is not, for Kafer, in the isolated individual communing with their technology, but in the social space formed through 'complex and contradictory negotiations with technology, [and] the ways in which such negotiations lead to questions about community, responsibility, pleasure and complicity'.[161]

In both Rodney's conception and the deliberations of Donald Rodney plc, *Autoicon* well exemplifies such a set of 'complex and contradictory negotiations with technology'. Writing in the journal *Mediascape* in the months following Rodney's death, Mike Phillips sketched out a preliminary, three-part technological structure for the work, including: 'Digital Body', 'Web Crawler/Montage Machine' and 'Artificial Intelligence'. Drafted before meetings of Donald Rodney plc, this early plan aspired to create a navigable 3D 'flythrough' of Rodney's 'digital body' through use of his medical documents – an intention that did not materialise in the finished piece. In the following meetings of Donald Rodney plc, members of the group voiced concerns about how medical images and data of bodies (both Rodney's and others') might be encountered by the user of the work. While Phillips relayed Rodney's interest in paralleling his physical body with a body of medical data, drawn by the 'ghoulishness' of such a document, both he and Diane Symons also raised the importance of displacing the use of Rodney's body from the particular into the realm of the political. That the interactive 'flythrough' did not ultimately manifest in the holistic environmental manner originally proposed is the result, perhaps, of both logistical and ethical limits, as well as an understanding of Rodney's resistance to the body experienced as a representational whole. The eventual integration of the artist's biomedical documents in *Autoicon* is, however, already foreshadowed in the *Mediascape* article, particularly in Phillips's depiction of the proposed role of artificial intelligence: '[T]he use of a Java-based "Artificial Intelligence" will allow users to interact with the digital body through text-based and audio conversations and user-interaction. A neural network would be incorporated to allow the body to learn about specific users' requests and conversation styles and follow up on previous dialogue.'[162] A neural net is a form of machine learning that mimics the structure of the human brain. In rudimentary terms, the learning is a reiterative process of guessing, self-correction, back-propagating, guessing and so on. The level of sophistication of the learning depends on the density of the net, and on the extent of data input and interaction. Rodney's decades of interactions with doctors and hospitals had yielded a vast data trail, a body of information that constitutes open-ended potential for such valorised autonomous intelligence. Echoing Rodney's own dark humour, Phillips noted: 'It is rare to find such a perfect, detailed document of a body's biological deterioration.'[163] In *Autoicon's* integration of various

abstractions of the body – cytogenetic maps, X-rays, computer renderings of sickle cells – into its web of conversational exchange and morphing montage, this 'perfect' document of deterioration is realised otherwise, in resistance to its potential as biocapital. The body is not made available as a comprehensive databank within frameworks of recursive learning and value production, but instead appears as a mobile assemblage of representational fragments, implicitly tied to the spectre of Rodney's fleshly presence as well as to the interdependent, collective labour of Donald Rodney plc and *Autoicon*'s users.

Autoicon mobilises questions of 'community, responsibility, pleasure and complicity', but crucially does so with regard to what might be considered a foundational rupture in the social: the experience and communication of physical pain. As evidenced in a number of audio and text excerpts in *Autoicon*, and in other works, Rodney repeatedly interrogated the impasse between the corporeality of pain and the burden of its reporting: as an imperative within medical frameworks in order to receive treatment; as a barrier or conduit between self and other; as an epigenetic trace of the violence of colonialism, the transatlantic slave trade and imperialism, and therefore of the inscription of the black body; and as a metaphorical device entangled with diagnoses of disease in the social body. In a 1994 interview, Rodney questioned:

> *How can you evoke pain within an image? You can be sitting next to me and say you feel pain, but how do I know ... whether you are feeling pain or not, or if your pain is anything like my pain. ... I'm trying to portray physical pain; the kind of pain I have experienced.*[164]

Elaine Scarry's 1985 book *The Body in Pain: The Making and Unmaking of the World* provided an important reference point for Rodney with regards to these questions. For Scarry, the experience of physical pain is unique in the 'whole fabric of psychic, somatic, and perceptual states' in its lack of an object outside the boundaries of the body. As such, it cannot be objectified in verbal or material form, but 'makes pressing the urge to move out and away from the body' through invention and imagination.[165] Rodney's address of pain circumvents any personalised mode of documentation or autopathography, but takes on a deeply political agency. Through the dialectic between the inscribed and data-mined body, on the one hand, and the incommunica-

bility of pain, on the other, *Autoicon* speaks to a relationship between the affected and affecting body as it exists within and beyond language. The work assembles acts of self-and-other narration at the site of Rodney's body, rendered within a medical informatics still beholden to scientific racism and to anthropological logics of cultural difference and ability. As such, it resonates with Pickens's words in addressing Audre Lorde's *The Cancer Journals* (1980), in privileging the 'body's power to speak for itself, as a focal point for generating political power and creating viable communities'.[166]

'Home as sanctuary as body in a state of siege'

Executing his patron's wishes in 1833, Thomas Southwood Smith stuffed Jeremy Bentham's skeleton with 'hay and tow' and located his wax bust on an iron spike at the top of the vertebrae. Engineering a somewhat stilted upright posture, Smith seated the Auto-Icon in its wood-and-glass case, resplendent in casual frock coat, pantaloons, waistcoat, high-collared Regency-style shirt, frilled cravat and straw hat, a gloved hand resting on Bentham's favourite walking stick. In his 1987 work *The House that Jack Built* (fig.19), Rodney mimicked this bodily construction using a striped cotton shirt and pair of paint-splattered grey trousers stuffed with straw and a wooden armature, seating the assemblage on a roughly built chair with protruding nails. Positioned in front of a grid of X-rays shaped into the outline of a house and bearing white stencilled texts and painted silhouettes of hands and scissors, the figure seems to be held upright by a crudely fashioned, bare tree trunk emerging from the sculpture's plinth, passing through the shirt and its collar and tapering at an angle upwards. A sparse branch extends from the apex of the trunk and is visually met by the outline of a hanging noose, painted onto the X-ray backdrop. In his 1998 essay 'His Catechism', chronicling Rodney's life and work, Eddie Chambers relays the testimony of an unnamed school pupil experiencing the work in a group exhibition in Nottingham in 1990:

> *I liked the picture called* The House That Jack Built. *I liked it because I think the artist has an illness and he is showing it by using his X-rays in his picture. I think he is not afraid to show his illness. The X-rays are in the shape of a house and he has put writing all over them. There is like a person sat on a chair of nails, this person has*

*no head but a kind of branch instead. I think the nails may repre-
sent pain, he's got lots of pain in his back.*[167]

As Chambers observes, despite the multilayered and wide-referencing
nature of the work, the pupil's response was tellingly perceptive. The 'tree'
made of black plastic piping is paired back to a few unadorned branches that
read like giant thorns; in its imaging of 'lots of pain', it is more unequivocal
than Frida Kahlo's ionic spine substitute in *Broken Column*. The work itself,
however, proposes another reading. At the bottom left of the X-ray house, a
stencilled text states: 'SELF PORTRAIT WITH BLAK FAMILY TREE AND
ANCESTRAL HOME.' If the viewer is to take this intertitle literally, then the
spinal tree – simultaneously a piercing armature for a body and a gallows
for a hanging – can also be read as both an evocation of ancestorship, 'the
vast terrain of Black history', and a repudiation of the conceit of the heredi-
tary line.[168] In his work of the 1980s, Rodney often used the terms 'Blk' or
'Blak' to signify a unifying black culture and political consciousness built
around a Pan-African identity.[169] In the poetic fragments written over the
X-rays, the titular 'house that Jack built' is articulated as a diseased imperial
edifice 'BUILT ON 75 MILLION DEAD BLACK SOULS' and contrasted
with the strength of ancestral blackness: 'MY FAMILY TREE HAS ROOTS
MUSCLE DEEP.' Yet, the house is also cast as a metaphor for the body riven
with vulnerability, with Rodney's text recalling the purgatorial 'hollow men'
of T.S. Eliot's 1925 homonym poem in a passage that states: 'I SIT HERE
WITH THE HOLLOW MEN WAITING FOR THE SHADOW TO FALL
AND INSIDE I CAN HEAR THE DRUMS BEAT OUT S.O.S.'

Taken as a whole, the stanzas of stencilled text narrate a political awak-
ening through the reading of a 'BOOK ON BLAK HISTORY', with the cul-
mination of this journey lying in a moment of liberation that is also one of
material dissolution. The inscription 'WHISPERS FILL EACH ROOM IN
MY ANCESTRAL HOME CHANTING DOWN JERICO WALLS' invokes
the Rastafarian belief in a return to an African homeland and the God-given
power to bring down the walls of occupying cities, as the 'wordsound' of col-
lective voices penetrates and dissolves the mortar between stones. *The House
that Jack Built* foregrounds the power of language, sound and knowledge as
forces of resistance, always in relation to the corporeal experience of inte-
rior and exterior affect. Yet, as figures of both institutional containment and

cultural belonging, the overlapping terms of house and home render a para-doxical state of both control and sanctuary. In notes written while producing the piece, Rodney ruminated: 'What is culture and how is it housed? Within Black culture in the West we diaspora we contain Black culture we house our own culture since so much else has been taken away and housed inside other bodies as part of British colonial past ... Home as sanctuary as body in a state of siege.'[170] If the diasporic body is fashioned in this statement as a refuge against extractive approaches to culture, Rodney's use of X-rays to make the form of a house also points to the role of the natural and human sciences in the state of siege that afflicts the body. Referencing the historical role of medical science in constructing and representing the 'normative' body – i.e. the white, male and abled hereditary subject – *The House that Jack Built* powerfully en-gages the entanglement of conceptions of physical capacity and sickness with constructs of race. As a self-portrait inhabiting both the ideological realm of the statuesque auto-thanatography and the scientific realm of biomedical diagnostic imaging, the piece is an important forerunner of *Autoicon* – a pre-figuration of its digital body-cum-sanctuary that is conscious of its own siege-like condition, but remains radically open, hospitable and penetrable.

The figuration of the 'body in a state of siege' returns in a number of Rodney's works of the mid-1990s, including *Flesh of My Flesh* (1996, fig.20). A monumentally photographic triptych on aluminium, the piece consists of three abutted images operating at two different scales of close-up documen-tation. While the central image shows a scar from a poorly stitched wound on Rodney's body, the other two were taken with an electron-microscope, picturing knotted hair strands. Seen together, in their placement and tonal similarities as surfaces lit by strong clinical light, the three images create the illusion of a continuous line, from hair to stitched skin and back to hair. The sublime quality of this assembled abstraction is tempered by the severity of the central scar as an image of pain. A remnant of a hip replacement opera-tion, the level of scarring is evidence of the work of a surgeon who, nurses later reported to Rodney, had felt that heavy overstitching was necessary as 'black skin is tougher than white skin'.[171] The photograph documents a physical assault, one driven by a persistent myth of racial difference and enacted under the auspices of medical care. Taken by Rodney's friend, the artist Franko B, the image can be read beyond the evidentiary, through the potent aesthetics of the wounded body. The flanking images of hair strands

are, in a different fashion, also a register of an artistic interaction, in this case between Rodney and Rose Finn-Kelcey. The by-product of a collaborative exhibition by the two artists at Ikon Gallery in Birmingham, the microscopic photographs of Rodney's and Finn-Kelcey's hair strands were part of a trialling of possibilities that did not make it into the show. Under intense close-up, the hairs appear identical, revealing no hint of variation in colour or type, or, of course, any ascribed markers of gender or racial difference. Through its title, *Flesh of My Flesh* references the Judeo-Christian creation story and a conception of material sameness between man and woman that simultaneously establishes a relational and semiotic hierarchy – woman 'taken out of man'. While the scientific image might be technologically keyed towards ever more molecular dissections of the composition of human physiology, and therefore an evidence of sameness within humanity, its social role is structured around the tracking of difference, anomalies and disorder.

First exhibited in the show 'Body Visual' at London's Barbican Centre in 1996, and then in hospitals around the UK, *Flesh of My Flesh* is in some ways bound to the context for which it was made.[172] Produced by Arts Catalyst, an organisation working across the arts, science and technology, 'Body Visual' brought together new works by Rodney, Helen Chadwick and Letizia Galli. The premise of the project responded to modern medical science's production of 'images of our biological beings that permeate our culture and our sense of identity',[173] and involved discussion and collaboration between the artists and a group of scientists and doctors. As part of his research, Rodney established dialogues with Dr Alison Bybee, a molecular biologist studying blood 'disorders', and Dr Elizabeth Anionwu, a leading health care expert who founded the first sickle cell and thalassemia counselling centre in the UK in 1979. Bybee contributed a text to the exhibition catalogue describing the process of completing a DNA test on a blood sample from Rodney. The separation of DNA strings allows identification of the original sequence of building blocks in one single gene. Bybee confirmed that for this gene, 'the DNA test shows that Donald is just like every other normal person', implying, however, that his sickle cell condition marked him out as the bearer of an abnormal gene yet to be located: 'One gene down, one hundred thousand to go.'[174] A geographically specific genetic adaptation, sickle cell trait enables resistance to malaria; but if two copies of the altered gene exist in an individual, the result is sickle cell anaemia. In Bybee's description: '"Sickle" haemoglo-

bin polymerises (gels) when it gives up oxygen. Repeated gelling deforms the blood cells into crescent or sickle shapes, which block the blood capillaries, causing intense pain and progressive deterioration of the affected organs and joints.'[175] The present-day distribution of sickle cell disease globally registers histories of forced displacement and migration from regions where malaria has been historically prevalent. The condition's presence amongst people from Africa and the African diaspora has been rendered in the Global North into a discursive entanglement with race that has, in Rodney's experience and that of many other black patients in the UK, led to its outright dismissal or deflection onto racialised constructs of debility.[176] An activist, carer and re-searcher, Anionwu conducted surveys in the 1980s that established a lack of understanding around sickle cell disorder amongst doctors and nurses, and found that stereotyped perceptions of black patients as 'trivial complainers' and 'time wasters' with 'lower pain thresholds' coalesced dangerously in the event of a sickle cell crisis. In campaigning for the establishment of screen-ing programmes for the presence of the sickle cell trait, Anionwu found au-thorities unwilling to fully pursue them based on racist beliefs that 'the black community were not educated enough to understand genetics and the high number of single black mothers would make it difficult to trace fathers'.[177]

Susan Sontag famously addressed how 'mysterious' diseases of the modern era (from tuberculosis to cancer and AIDS) have historically been both tied to individual character (as punishment or expression of repression) and taken on metaphorical figurations in society and culture in relation to the health of the body politic.[178] It is not hard to see similar logics at work as the backdrop to the discriminatory treatment of sickle cell patients. As Rodney articulated in his press release for 'Crisis', within the social and po-litical imaginary of the postcolonial world, the so-called 'race problem' has been routinely imbued with the metaphorical character of sickness, disease and 'blight'. In preparing for his 1990 solo exhibition 'Critical', Rodney collected 150 quotations from newspapers 'relating "social" economics in medical terms'.[179] Militarised medical metaphors of cellular invasion and defence against attack bleed into the political rhetoric that circulates around immigration in the UK – sentiments that were particularly acute following the arrival of the Windrush generation of migrants from the Caribbean in the late 1950s, which included Rodney's parents, and that persist in the on-going intergenerational structures of the 'hostile environment'.[180]

Both Bybee's essay and another by curator David Thorp in the catalogue for 'Body Visual' suggest that Rodney originally planned for the DNA image to form one of the flanking parts of the *Flesh of My Flesh* triptych. Presumably with the hair strands composited into one image on the opposite side, the DNA test would provide a parallel representation of sameness as evidenced by ever more molecular dissections of scientific analysis. Rodney's eventual decision to not use the image is one that revises the work both formally and conceptually, a move that registers a subtle resistance to the informatic order of the DNA test and its translation of a material condition into a question of coding. In his 2000 book *Against Race: Imagining Political Culture beyond the Color Line*, Paul Gilroy optimistically references the story of Henrietta Lacks, a working-class African-American woman whose cervical cancer cells were used – without her consent and after her death in 1951 – for medical research that resulted in the first 'immortal' human cell line to be identified, generating invaluable data. For Gilroy, Lacks exemplifies the 'awareness of the indissoluble unity of all life at the level of genetic materials' and therefore a passage from the 'biopolitics of "race"' to a 'nano-politics' that heralds the 'demise of race'.[181] Questioning this pronouncement, Denise Ferreira da Silva argues:

> *That cancer cells do not indicate dark brown skin or flat noses can be conceived of as emancipatory only if one forgets, or minimizes, the political context within which lab materials will be collected and the benefits of biotechnological research will be distributed. ... Across the earth, women still die of cervical cancer despite the advances Lacks's stolen cells have enabled, but they do not die the same way. Economically dispossessed women of color, like Lacks, die with more pain and no hope.*[182]

In *Flesh of My Flesh*, the tension between what da Silva calls a 'humanist desire' of 'emancipation' through the 'liberating powers of ... biotechnology', on the one hand, and the 'materiality (body and social position)' of Rodney as a black man with sickle cell disorder, on the other, is pulled tight in the visual line running between the knotted hairs, blown-up as large as tree branches, and the tortuously irregular scar. In excluding the DNA image from *Flesh of My Flesh*, Rodney shifted emphasis away from a linear progression of increasingly granular visual information – from 35mm film photography,

to electron microscopy, to electrophoresis – towards a 'punctum' that penetrates the social and the scientific: the personal experience of pain; the (im)possibilities of its communication; and the power-ridden nature of this disintegration and usurpation of language.

The central image of *Flesh of My Flesh* functions as an account of two events: the scarification of the flesh caused by the surgeon; and the act of bodily presentation for the camera, arranged with a visiting artist friend. While the former marks the translation of Rodney's pain into an insignia of the power wielded by a structurally racist medical establishment, the latter transgresses and thwarts this inscription. The visceral refiguration of 'fleshiness' is central to this critical move. Writing about the transatlantic slave trade, scholar Hortense J. Spillers defines the distinction between 'body' and 'flesh' as the 'central one between captive and liberated subject positions'. The flesh is a 'primary narrative' – 'that zero degree of social conceptualization' – constituted in the violent 'theft of the body' in the Middle Passage. Spillers does not repeat the myth of human genesis as 'bone from my bones and flesh from my flesh', but rather describes an ever-present besideness to flesh and its capturing through signification as the body. In her address of the torture and mutilation of enslaved people performed as a constitutive part of plantation culture, she pinpoints the material imbrication of race and disability that inaugurates anti-blackness as a normative condition:

> *These undecipherable markings on the captive body render a kind of hieroglyphics of the flesh whose severe disjunctures come to be hidden to the cultural seeing by skin color. We might well ask if this phenomenon of marking and branding actually 'transfers' from one generation to another, finding its various symbolic substitutions in an efficacy of meanings that repeat the initiating moments? ... This body whose flesh carries the female and the male to the frontiers of survival bears in person the marks of a cultural text whose inside has been turned outside.*[183]

Spillers's work enables an understanding of the brutal corporealisation and fixing of the black body beyond the non-events of abolition and emancipation; but equally of blackness as the centre of social struggle. Rather than suggesting the possibility of escape from the imposition of body upon flesh

– those juridical, legislative and scientific moments of inscription of the black body[184] – Spillers looks at the 'eventfulness' of being in the flesh as offering 'a praxis and a theory, a text for living and for dying, and a method for reading both through their diverse mediations'.[185] Taken up by Saidiya Hartman in her exploration of the 'performance of blackness', such an eventfulness consists of counter-investments in the body that entail 'a protest or rejection of the anatomo-politics that produces the black body as aberrant'.[186] The image of Rodney's scar that forms the locus of *Flesh of My Flesh* can be read as a 'cultural text whose inside has been turned outside'. In the work's critical and performative re-tooling of the semiosis of scientific observation towards a figuration of pain denied and replaced by terms of power, Rodney foregrounded the eventfulness of being in the flesh.

The body in pieces

Both the DNA test produced by Dr Alison Bybee and an image of Donald Rodney's skin appear as artefacts in *Autoicon*'s database, joining a small bank of medical documents, X-rays and scans. In the CD-ROM version, the DNA test is used as a backdrop to the 'chat' landing page and in some of the pop-up text responses. In the original Web version, the landing page located within the Iniva website was composed of a close-up photograph of a small detached fragment of skin against a white background, with three superimposed circles marked 'A', 'B' and 'C' in the manner of a marked-up medical image (fig.14). Clicking on these circles would take the user to three different parts of *Autoicon*: the introductory text, the chat function and the biography site. Appearing as a torn and unfolded piece of paper or parchment, its surface showing epidermal lines and creases, the skin fragment was the remnant of a surgical procedure undertaken on Rodney's body. Unlike the tests and scans, it was not 'produced' to yield diagnostic information, serving no immediate medical utility, and thus was considered 'waste'. In its re-presentation, however, it signifies beyond the scientific realm, suggesting a prior act of physical wounding or repair, and, at a more general social level, isolating the role of skin and its pigmentation within logics of race. As a digital object – a threshold to be interacted with in order to access *Autoicon* – the skin fragment takes on an ambiguous role as a material trace of Rodney. It is both specific to him and made mutable and porous through medical and informatic intervention; it bears the weight of presence and touch, while im-

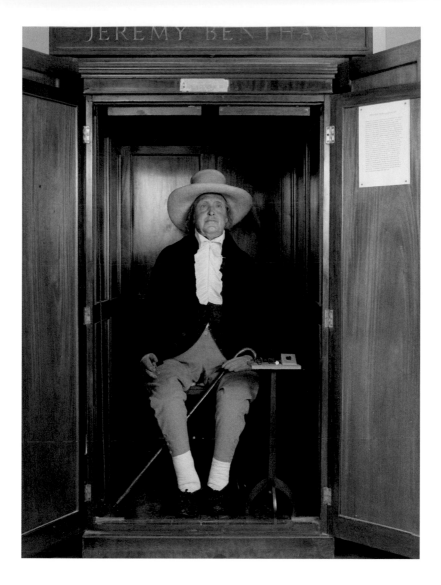

24. Jeremy Bentham's Auto-Icon, 1833.
© UCL Educational Media

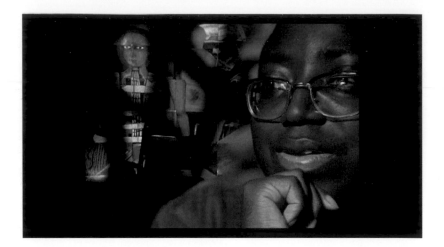

Above:
25. Trevor Mathison and Edward George,
Three Songs on Pain, Time and Light,
1995, colour, sound, 25min. © Smoking
Dogs Films, All Rights Reserved, DACS/
Artimage 2023. Courtesy Smoking Dogs
Films, Lisson Gallery

Below:
26. John Akomfrah, *The Genome
Chronicles*, 2008, single-channel HD
colour video, sound, 32min 46sec. ©
Smoking Dogs Films, All Rights Reserved,
DACS/Artimage 2023. Courtesy Smoking
Dogs Films, Lisson Gallery

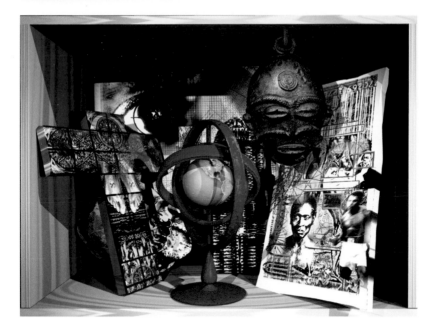

27. Keith Piper, *Relocating the Remains*,
1997-99, CD-ROM. Courtesy the artist

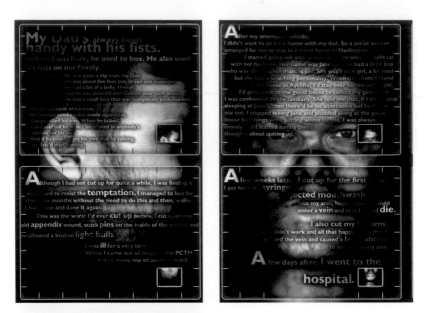

28. Graham Harwood, *Rehearsal of Memory*, Book Works, 1995, CD-ROM. Created with patients and staff of Ashworth high-security hospital, Liverpool, UK. Courtesy the artist

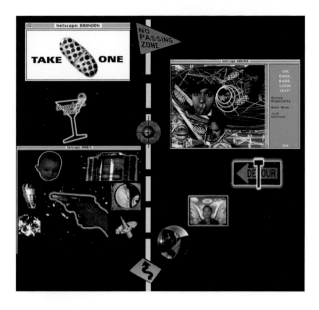

29-30. Shu Lea Cheang, *Brandon*, 1998-99, interactive networked code (html, Java, Javascript, server database). Courtesy Shu Lea Cheang and Solomon R. Guggenheim Museum

31. Roshini Kempadoo, *Sweetness and Light: the head people*, 1996, photocon-struction from digital artwork produced for online exhibition 'La Finca/ The Homestead'. Courtesy the artist

32. Carolyn Lazard, *In Sickness and Study*, 2015-ongoing, digital photographs. Collection of the Museum of Modern Art, New York, Fund for the Twenty-First Century. Courtesy the artist and Maxwell Graham Gallery, New York

Kunsthalle Bern

Archive

Park McArthur
Kunsthalle_guests Gaeste.Netz.5456
15 August – 4 October 2020

Jump to text

5456 01:04
▶

Entrance Hall 02:12
▶

Ostsaal 01:54
▶

Westsaal 01:23
▶

33. Installation view of Park McArthur,
'Kunsthalle_guests Gaeste.Netz.5456',
Kunsthalle Bern, 2020. Courtesy the
artist and Maxwell Graham Gallery,
New York. Photo: Gunnar Meier

[A touch screen cell phone lying on a flat
surface of grey marble with white vein-
ing. The phone's screen displays a Web
address beginning 'kunsthalle-bern.ch/
en' and lists a series of sound files with
corresponding play buttons underneath
the title and date information 'Park
McArthur Kunsthalle_guests Gaeste.
Netz.5456 15 August–4 October 2020'.]

plying a vulnerability to fragmentation that is sociogenically inscribed.[187] In its interfacial function, it emphasises an interplay between inscription, as a free-floating system of signs, and incorporation, as something inextricable from its embodied medium.[188]

The piece of skin photographed for *Autoicon* is itself a remnant from Rodney's work *My Mother, My Father, My Sister, My Brother* (fig. 21, 1997), exhibited in '9 Night in Eldorado' alongside its partner work, *In the House of My Father* (1996–97, fig.22). For the former work, exhibited on a small Perspex shelf, Rodney fashioned a rudimentary form of a house, around three centimetres square in size, using the fragments of his skin, clothing pins and clear tape. The latter work comprises a large photograph of this sculpture resting in Rodney's hand, laid palm up on a white hospital sheet. Due to its fragility, *My Mother, My Father, My Sister, My Brother* has rarely been exhibited since 1997, while *In the House of My Father* has been presented on a number of occasions and come to exist independently of the material object at its centre. Considering the two works together, however, confers an inseparable relationship between object, the event of its making and that of its presentation for the camera in Rodney's hand. In the context of '9 Night in Eldorado', which foregrounded a sense of absence both in the aftermath of the death of Harold Rodney and in Donald Rodney's diminished social presence due to recurring hospitalisation, the skin, tape and pin house would have taken on a highly ephemeral and spectral presence. Yet, the performative aspect of *In the House of My Father* offers it up in another light. Positioned in the centre of Rodney's palm, it seems to hold weight as the hand rests on a hospital bed. While still ephemeral and makeshift, and prone to being crushed under the closing hand, the house is proffered as an act of careful construction – a fragile container and shelter, doubled by the act of holding. Echoing the X-ray house in *The House that Jack Built*, the barely held-together structure of skin even more profoundly renders the image of 'Home as sanctuary as body in a state of siege'. Where the earlier work saw sanctuary and a 'lexicon of liberation' in black history and the 'Blak family tree', *My Mother, My Father, My Sister, My Brother* and *In the House of My Father* locate a fragile place of refuge in relations within and beyond filial ties. They offer a figuration of material life bound up with an understanding of presence beyond such a physical horizon.

In an essay on *In the House of My Father*, Diane Symons draws a connection between the photograph's cropping of Rodney's arm, the modular materiality of the skin house and art historian Linda Nochlin's concept of the 'body-in-pieces'. Nochlin considered recurring representations of dismembered or partially cropped bodies in Western art from the late eighteenth century onwards as a paradigm of the 'subject under consideration'.[189] The anatomical body, assembled and disassembled, was for Nochlin an expression of the experience of modernity as a 'vanished wholeness', a fragmentation that modern artists both depicted and desired to overcome through the higher unity of art.[190] In line with the posthumanist opposition to such 'will to totalisation', the meeting of hand and detached skin in *In the House of My Father* is perhaps to be seen as a cyborgian gesture of the dissolution of epidermal boundaries – 'Why should our bodies end at the skin?' In an imagined state of bodily integrity, the skin holds a liminal status as both a protective container for the body and its meeting point with the world. In the reality of the body as mutable, regenerative and prone to wounding, this site of meeting is one of porosity and exuviation. Nirmala Erevelles states that 'experiencing bodies are constantly crossing boundaries (through touch, through the stare), and as a result, all bodies are in a constant state of renewal and adjustment in changing physical and environmental contexts, making the body intensely aware, not just of its be-ing but also of its becoming-in-the-world'.[191] Rodney's skin house, as an enclosed but penetrable form, serves as a tentative archival gesture, one wilfully riven with affectability rather than the intent to preserve. If the skin-on-skin doubling of the epidermal fragment placed on its originating body suggests material equivalence and modularity, in the photograph's pose, the cropped arm points to a haptic extension of the out-of-shot subject. Through its performativity, the scene brings into the frame the context and felt experience of its production. The work of *In the House of My Father* is both that of artistic creativity (the making of *My Mother, My Father, My Sister, My Brother* by the very hand that holds it) and the work of the sick body – that which keeps the 'body and soul together' within disjunctive experiences of time, from crisis to prolonged care. The time that this work marks is that of hospitalised waiting, encapsulated in the word 'patient', but also the time of eventful making, not as an insistent force of productive labour but as a point of affective connection. As Scarry articulates, 'Work and its "work" (or work and its object, its artefact) are the names

given to the phenomena of pain and the imagination as they begin to move from being a self-contained loop within the body to becoming the equivalent loop now projected into the external world.'[192]

Twenty years after its making, resonances with *In the House of My Father* emerge in artist Carolyn Lazard's ongoing *In Sickness and Study* series (fig.32). In 2015, Lazard began to photograph the covers of books they were reading while undergoing periodic drug infusions to treat their chronic illness, posting the images on the social media platform Instagram. The accumulation of these images online, along with their presentation in a gallery as a series of screenshots, serves to mark the open-ended nature of Lazard's treatment – a prolonged temporality underscored by the gradually evolving interface design of the platform. In each photograph, just Lazard's hand and arm are visible, holding a book, with intravenous infusion lines in the foreground and the hospital surroundings visible in the background. The extended arm mimics the smartphone-holding posture assumed when taking a selfie. Yet in this instance, with the camera situated to follow Lazard's gaze onto the book in hand, the photograph images the act of reading as a marker of positionality, in place of capturing a self-portrait as a performance of identity. The books that are documented – spanning speculative fiction, disability studies, feminist theory and black studies – speak to Lazard's personal negotiation through study of proximity to intersecting identities, while the resulting photographs' public distribution posits an imagined (and potentially actual) community and shared canon of knowledge and thought.[193]

In Sickness and Study also, however, makes tangible the fugitive relationship between such a recalibration of time towards study, and the dehumanising experience of medicalisation. For Lazard, the hospital is both a space of surplus – the accrual of bodies socially and economically prescribed as incapacitated – and the capitalist capture of this surplus, through the valorisation of the healthcare system. The repetition and seriality of the images posted to Instagram suggest an element of Fordist labour in the ergonomic symbiosis of machine and body, and such labour's persistence in the post-Fordist arena of cognitive capitalism. Here, the constant absorption of knowledge and its relay into the world is a central technique on the production line of self-improvement and economic viability. *In Sickness and Study* emphasises how, in Lazard's words, '[t]he increased virtuality of labor, not unlike the administering of biomedical technology, is meant to make life

more convenient. ... And yet as advanced capitalism has deemed the physical body an obsolete, outdated tool, the body still remains.'[194]

The 'body-in-pieces' implicated in *In Sickness and Study* is fragmented through biomedicine's molecular repair, and the partitioning and experiential extension of the body as a prerequisite for productivity within digital and biotechnical capitalism. Within the logic of regenerative care keyed towards the reproduction of labour power, the nature of the *perpetual* labour undertaken by those living with impairment or illness in order to contend with disabling structures is occluded. Lazard's work – and, in synergetic ways, that of Rodney too – indicates that to think and feel as an artist from the position of incapacity is not to invoke the Kantian 'purposeful without purpose' of the aesthetic, as a condition oppositional to the capitalist imperative to sell one's labour power. Rather, it is to insist on the visibility and affectability of the labour of disability, and its value inside and outside of capital. Or, in the words of artist Constantina Zavitsanos: 'Work is for one thing only, and that's to provide for the needs or conditions of life, to *condition* life. All work is care work. Until we see all life-and-death as invaluable ... we won't really recognize labour – precisely because we will have failed to recognize the dependency we share.'[195] Rodney's adaptation of the hospital environment towards research, organising and production is prone to being mythologised as a narrative of heightened productive capacity. Yet, when seen in the light of works such as *In the House of My Father*, and in consideration of *Autoicon* as a set of ongoing negotiations with the coded and fragmented body, and with other interacting bodies, this adaptability centres instead a mode of work harnessed to the interdependence of capacity and debility; to shifting intensities and vulnerabilities, and noncompliant notions of time, presence and affect.

'bodies as places to meet'

Included in the database of materials composing *Autoicon* is a video of the opening night of '9 Night in Eldorado' at South London Gallery, an occasion that Donald Rodney was unable to attend. The video is in many ways a neat analogy for *Autoicon* itself, showing a convivial gathering in the absence of its central subject, but in the presence of his work and collaborators. The footage records a familiar scene of congregating friends, drinks in hand, with some peeling off to view the exhibition. The videographer focusses in

on another active presence in the space: the work *Psalms* (1997, fig.23), a motorised wheelchair that of its own accord plots a route around the gallery. Occasionally the wheelchair can be seen encountering an obstacle in the form of a person deep in conversation, stopping for several seconds then changing its orientation and continuing its journey. The wheelchair seems to haunt the room, silently approaching groups of people chatting and drinking. It is hard not to read *Psalms* as a surrogate for Rodney, the wheelchair's interactions gesturing towards the expected bodily and social labour of artistic mediation, and underscoring its notable absence and the artist's presence elsewhere. Rodney had been developing the work for a number of years, with sketches of wheelchairs appearing in his notebooks from 1993 onwards. The rudimentary sensing and self-governing character of the wheelchair was designed by Guido Bugmann, a computer engineer at University of Plymouth with expertise in robotics and brain modelling, whom Mike Phillips linked up with Rodney. Bugmann and his colleagues modified a wheelchair using 'eight sonar sensors, shaft encoders, a video camera and a rate gyroscope', and mounted a laptop-based control system to it.[196] A neural network plotted a trajectory for the wheelchair according to Rodney's instructions, comprising a repeated sequence of circles, spirals and figures of eight, while also enabling the rudimentary decision-making required to negotiate obstacles.

While Rodney's earlier sketchbook imaginings of *Psalms* include lyrical embellishments to the chair, such as the 'encrusting' of its surfaces with bird shapes cut from X-ray plates, its final iteration is tellingly pared down to the wheelchair and its necessary customisations. When *Psalms* is experienced today – the work's functionality is still maintained by Phillips and Bugmann in each instance of its exhibition – its technological anachronisms appear merely as ones of computational scale and capacity. The proximity of its ingenious premise to the contemporary technology of self-driving vehicles highlights the developmental contradictions between what are considered 'assistive' or 'time- and labour-saving' devices, with neoliberal capitalist value located in both the productive body and imposed debility. While the customised chair exudes technological abundance, in *Psalms* this machinic presence is superseded by a profound sense of bodily absence. The exhibition coordinator of '9 Night in Eldorado', Jane Bilton, described the work at the time as on 'a journey to nowhere. ... Its movements repeat, like an ever-recurring memory, a memory of another life and another journey.'[197] This reading, which connects

Psalms to Rodney's father's diasporic journey, is layered with Rodney's own experience of low physical mobility brought about by the gradual necrosis of his joints, and his necessary use of mechanical adaptations as aids. *Psalms* is in theory perpetually in movement, but in reality constrained by its negotiation of gallery visitors, technological limitations and the architecture of the host institution – a circulatory site of labour where productivity and the maintenance of a journey, a life, are subsumed within a temporality of fits and starts. Yet while a viewer experiencing *Psalms* might be tempted to read such moments of constraint and recalibration as machinic dysfunction, they are also legible as events of meeting and affective destabilisation.

Despite the critical deconstruction of categories and boundaries in Donna Haraway's cyborg theory, in popular conceptions the synthesis of body and technology creates a discrete unity. As Alison Kafer and other crip theorists have articulated, the image of the disabled body as cyborg, permeable with 'prosthetics, ventilators or attendants', has all too often been used to perpetuate distinctions between 'normal' and 'abnormal' bodies, 'eclips[ing] disabled muscle and bone'.[198] In *Psalms*, the absence of a person using the wheelchair destabilises the idealisation of the human/machine hybrid. The body is fully replaced by the coding of patterns of information, an abstraction of 'sensed' environmental data that is then decoded into a set of instructions for responsive movement. This substitution is most profoundly registered at the moment the wheelchair encounters a person in space, scans them through its rudimentary sensors, receives information on their mass and co-ordinates, and responds through a recalibration of its trajectory. This meeting of human and machine is, on one level, a set of calculations, a rendering and melding of bodies and technological parts on informational terms. On another level, for the viewer, it is a complex of imaginings of surrogate personhood, gestural exchanges between projections of the mind, territorial negotiations and unstable proximities. The autonomous wheelchair might plot a pre-ordained lonely path around the gallery space, but its adaptations do not serve to normalise a (non)presence; they rather subvert an absence through an excess of sensing and interaction loaded with metaphorical meaning. In the moments of its wordless affective meeting with viewers and the mapping of its spatial confines, the work physically enacts the memory of Harold Rodney's life and passing, and his son's sense of loss.

The artist Park McArthur has written of her experience of participating in a care collective – a group of people caring for her as a person living

with limb-girdle muscular dystrophy type 2I (also known as LGMD-R9). Describing the encounter with others through acts of care born from dependency – what she calls 'care-as-event' – McArthur refers to the 'open materiality of bodies as places to meet'.[199] Bodily 'meeting', here, is a confluence of social conditions, obligations and desires: 'Care-as-event obeys and follows through transferences of weight and fluid and affect, creating, over time, an aesthetics in addition to an ethics.'[200] In her work, McArthur often re-presents industrial materials typically used for assistive, protective or containment purposes. These materials are designed to interact with the conditions of their environment through impact or absorption – a form of material sensing and permeation that complicates anthropocentric perceptions of autonomy. *Untitled* (2013) is a seven-minute-long audio recording made while the artist traced the space of a small room in her power wheelchair. The sound recorded is minimal, limited purely to that generated by the chair and its material interactions – a series of surface-against-surface contact noises and mechanical whirs. *Untitled* featured in McArthur's solo exhibition 'Kunsthalle guests Gaeste.Netz.5456', which took place at Kunsthalle Bern and on the institution's website in 2020. For the making and installation of the exhibition she did not travel to Bern from her home in the US.[201] Central to this exhibition was a series of audio descriptions of the Kunsthalle, written by McArthur using the memories and experiences of the space shared by employees, artists and art historians, and voiced in both German and English by a long-term employee (fig.33). These audio files form a walkthrough, from the building's exterior into its galleries, including descriptions of installed artworks by McArthur and, in the case of *Untitled*, the work itself. Listened to remotely through the Kunsthalle's website, the audio descriptions – available also as a written transcript and complemented by photographs – are a form of surrogate for an embodied experience of the building and in situ artworks. Accessed in the exhibition space through the Wi-Fi network and password listed in the title, they were an augmentation, drawing attention to objects, qualities and information not otherwise sensed or signposted.

McArthur's approach implicitly acknowledges a hierarchy in the experience of art, between bodily and mediated encounter, while problematising its underlying assumptions around the uniformity of how different people employ their senses in varying contexts. *Untitled* is encountered within an audio file labelled 'Elevator'. The audio description reports 'a type of lift known in

German as *Niederflurau_fzug*, "low floor elevator"', stating that '[a]n artwork is inside this description of the elevator'; and a basic outline of *Untitled* is provided before the audio work plays in its entirety. The inclusion of *Untitled* within the audio description creates a dizzying mise en abyme for the listener, either remotely projecting into the time and space of the Kunsthalle elevator's descent, and synchronically into that of the 'small room' traced by McArthur, or experienced from the Kunsthalle elevator itself, from one small space into another, knowable only through its acoustic resonances and the documented time taken to trace its topography.

The conception of 'Kunsthalle_guests Gaeste.Netz.5456' constitutes a work of collective care on behalf of McArthur and the community of the Kunsthalle. This care occurs in awareness of specific and general conditions of inaccessibility – whether as a result of social or physical barriers hindering those with an impairment or chronic illness from travelling to or entering the building; restrictions related to the COVID-19 pandemic and in effect during the exhibition's run; or social and economic structures of discrimination. But it also approaches the experience of distance as one of possibility rather than lack. McArthur asks critical questions as to what it is to know an environmental and institutional body – not as a text to be read, but as a shifting set of quantities and qualities that are conditioned and conditioning. The introductory text for 'Kunsthalle_guests Gaeste.Netz.5456' posits the exhibition as an 'invitation to reflect upon the confrontation of presence, and upon whom presence relies. ... What is presence if not a response to what and who is not there, to the objects and objectivities that are absent and may to a limited extent be our influence.'[202] Rodney's *Psalms* offers a comparable opportunity to reflect upon presence as a reminder of particular absences. The work, in its binding of narratives of journey and desire to a surrogate technological body, animates 'the relational, intra-personal, asymmetrical, non-reciprocal, non-recuperable parts of life', an operative quality that is carried forward as a formative aspect of *Autoicon*.[203] On its surface, *Autoicon* is a project of recuperation and preservation: of the body through biomedical data, and of Rodney's persona through documents of his life and work. Yet, in engaging with the work and the circumstances of its production, the user is confronted with a complex understanding of presence, its interdependencies and vulnerabilities.

As with other works in '9 Night in Eldorado' – most directly *Bible* (1997), which succinctly comprised Rodney's sister's heavily thumbed and coverless

copy of the Bible, imperiously presented high on the gallery wall – the title *Psalms* invokes the texts of Christian doctrine and Rodney's family history with the Pentecostal Church. *The Book of Psalms* is a gathering of sacred poems to be sung in moments of praise, grief, protest and pilgrimage, with the lyrics pronouncing the performance of music as an end in itself. This performative character intersects with that of the Nine Night ceremony, about which Rodney described 'each person almost venting the passages from the Old and [New] Testament they know it so well'.[204] The title of *Psalms* is undoubtedly incongruous in the presence of the largely silent motorised wheelchair, performing its recursive, ritualised movements in the absence of a voicing body.[205] But it attests to a notion of complex embodiment that contests the power of language and signification divorced from material conditions. Reflecting in 1989 on the role of the X-ray in his work, Rodney wrote:

> *Any medium at once affects the field of the senses, as the Psalmist explained long ago in the 115 Psalm*
> *Their idols are silver and gold / The work of mens hands / They have mouths, but they speak not; / Eyes they have but they see not; Noses have they, but they smell not; / They have hands but they handle not; / Feet have they but they walk not; / Neither speak they through their throat / They that make them shall be like unto them / Yea everyone that trusteth in them.*[206]

This biblical reference offers insight into Rodney's thinking around the X-ray as a medium, with a telling prefiguration of both *Psalms* and *Autoicon*. The latter, in the spirit of Bentham's Auto-Icon, sets out to generate an 'idolatrous' simulation of Rodney. But in the work's realisation through Donald Rodney plc, its ongoing interactions with users, its cutting and splicing of embodied sound, image and word, and its voicing of questions around pain (terms defined by Rodney himself), *Autoicon* asserts a contrasting politics of affect. Through transmission, sharing and circulation, it dissolves both the sense of a unified subject and reveals the false and mythological 'stable contours' of the organic body. While Psalm 115 makes use of bodily and sensory debility as a threat, *Autoicon* redeploys this threat to undo the myth of individual artistic subjectivity and foreground the reality of imbricated processes of co-production and care.

User: When will this work be complete?
Autoicon [sound file, recording of Donald Rodney]: ' ... exactly, and that's what this piece is about ... '

In a 1988 essay, Maud Sulter, artist and friend of Donald Rodney, posed a question: '[W]ho will be there to help you if your contemporaries no longer exist?' Addressing the erasure of black voices from history, specifically those of black women ('too many are dying of this epidemic of many which includes our rape, our murder, our poverty and our criminalisation'), Sulter argued against collusion with 'those who want to oppress our art,' stating that '[n]o one will document our future but us'.[207] Her rhetorical question powerfully holds up the 'nowness' of the contemporary against an ever-present threat of extinction, and mutual dependency and help against artistic individuation and institutional co-option. Sulter offers a vision of the archive wedded to the reciprocal documentation of futures, not the expression of historical fixity and authority. *Autoicon* takes up the urgency of Sulter's question through the care committed by Donald Rodney plc to its realisation and its continual reconstitution through the past, present and future engagement of users. This engagement marks a form of witnessing that eschews a removed observational position, but is constantly in tension with the 'right to opacity' enacted by the work – an insurgent re-tooling of informatics away from political, economic and juridical schemas, towards the haptic 'open materiality of bodies as places to meet'.

For some of those who were close to Rodney in his life, there is something monstrous in *Autoicon*'s insistent techno-futurist proposition fashioned around a space of loss, pain, memory and simulation. Unavoidably, the work resides within a number of seemingly conflicting states, strewn between the poles of digital utopianism and the persistence of material and historical realities. Firstly, the increasing intersections between the worlds of art, computing and communication technologies in the 1990s opened new possibilities for anti-commodity creative production and posthumanist explorations of subjecthood and the body; yet *Autoicon*, in its intrinsic relation to Rodney's decade-and-a-half address of the racialised, biopolitical power informing British social and institutional bodies, does not sit comfortably with techno-optimist fantasies of transcendence. Secondly, *Autoicon* sets out to maintain the personhood of the

artist Donald Rodney, as a singular composite of medical data, memory and creative output; yet this fails to align with the reality of Rodney's investment in co-production, and the manner in which his work challenges scientific and cultural conceptions of the individual self, both genealogically and sociogenically prescribed. Lastly, *Autoicon*'s presaging of the algorithmic and encyclopaedic digital technologies that have become deeply familiar in the first two decades of the twenty-first century – from search engine technologies to archiving tools and social media – elides the work's wilful embrace of gaps, inadequacies and incompleteness as well as Rodney's wider concerns with the occidental archive as a fulcrum of colonial and racial evisceration. These dialectics speak to the very nature of the relationship between life, technology and power as seen from the intersecting perspectives of blackness and disability. As Fred Moten writes about black studies, *Autoicon* is 'constrained to investigate ... the relationship between (the manipulation of) things and (the care of) selves', towards the juncture of 'technological breakthrough and technological breakdown'.[208]

In its critical understanding of how Rodney's life was being predetermined and negated by structural conditions, *Autoicon* is an act of evocation of the parameters of the artist's life seen otherwise. Echoing the rites of Nine Night, the work is intrinsically concerned with the cultural, social and material terms of the recuperability of life, and its holding in resistance to forms of violent extraction. This renegotiation of the terms of life is not oriented towards its prolonging, the dream of immortality, but towards a capacious notion of living and enlivenment. As a fugitive digital environment and fleshly animation, *Autoicon* deliberately employs organisational strategies that displace temporal, linguistic and proprietorial regimes, privileging instead a distributed understanding of creativity, knowledge and memory. It is perhaps telling that the rapidity of technological obsolescence in the twenty-first century led to the inoperability of *Autoicon* as an online space within a matter of years, in that it proposed an openness to absorption from and impact by its environment and users that has been largely corporatised and monetised within today's Internet ecosystem. Perhaps, *Autoicon* was conceived and produced in awareness of its own dissolution, less interested in reproducing its terms of creation and sustenance than in what might alter its conditions of emergence.[209]

Autoicon is 'alive', not because of its technological competency in simulating 'liveness' or in circumventing finitude, but because of its opacity, its gesturing always beyond itself to events past and yet to come. It is above all an articulation of un-measurable ways of being that exceed the body politic; an embodied voice – incisive, humorous, confrontational, mischievous, testing, critical, speculative – and its morphing into multiplicity through the intimacy, care and mutability of affective meeting.

Notes

1 Sylvia Wynter and Katherine McKittrick, 'Unparalleled Catastrophe for Our Species? Or, to Give Humanness a Different Future: Conversations', in K. McKittrick, ed., *Sylvia Wynter: On Being Human as Praxis*, Durham, NC: Duke University Press, 2015, p.25.

2 Sleeve notes to the CD-ROM *donald.rodney:autoicon v1.0*, produced by Geoff Cox and Mike Phillips; Science Technology Arts Research (STAR), University of Plymouth; Institute of International Visual Arts (Iniva), London; and Signwave, London, with support from the Arts Council of England (New Media Fund). With contributions by Eddie Chambers, Richard Hylton, Angelika Koechert, Virginia Nimarkoh, Keith Piper, Gary Stewart and Diane Symons. Media courtesy of the Estate of Donald Rodney and Black Audio Film Collective. Published by Iniva and STAR, 2000. The original Web version of the *Autoicon* introductory text can be found at https://i-dat.org/donald-rodney-autoicon/ (last accessed 13 January 2022).

3 'Donald Rodney', Celine Gallery, Glasgow, 11–27 June 2021, curated by Ian Sergeant.

4 Screenshots of the online manifestation of *Autoicon* can be accessed through the 'Wayback Machine', example page https://web.archive.org/web/20030919050505/http://www.i-dat. org/projects/autoicon/chat.cgi (last accessed 13 January 2022).

5 Net art is considered here to emerge with the advent of the World Wide Web and is therefore distinct from (although in many cases sharing characteristics and concepts with) prior network-based art that made use of telephones, faxes and the postal mail system. The use of computers introduces independent machine agency and information processing. 'Net art' bears a particular derivation from the term 'net.art', which was supposedly coined by artist Vuk Ćosić in 1995 and adopted by a loose 'school' of affiliated artists including Rachel Baker, Heath Bunting and Alexei Shulgin.

6 Kimberley Spreeuwenberg in collaboration with Annet Dekker, Constant Dullaart, Sandra Fauconnier, Sabine Niederer, Robert Sakrowski and Ward ten Voorde, 'Documenting Internet-Based Art: The Dullaart-Sakrowski Method' (research report), Culture Vortex: Public Participation in Online Collections, 2012, organised by Institute of Network Cultures, Amsterdam, available at http://aaaan.net/wp-content/uploads/2015/09/Document-ing-Internet-Based-Art_FINAL.pdf (last accessed on 13 January 2022).

7 R. Sakrowski, quoted in *ibid*.

8 *Ibid*.

9 This 'conversation' took place through the CD-ROM *donald.rodney:autoicon v1.0, op. cit.*

10 Named after the character of Eliza Doolittle in George Bernard Shaw's play *Pygmalion* (1913), ELIZA was created between 1964–66 by Joseph Weizenbaum at the Artificial Intelligence Laboratory at the Massachusetts Institute of Technology (MIT). ELIZA used scripts to guide its interactions, the most famous being a simulation of a Rogerian psychotherapist. Talkomatic was created by Doug Brown and David R. Woolley in 1973 at the University of Illinois and formed part of PLATO, a computer-assisted instruction system used in schools and colleges in the United States in the 1970s and 1980s.

11 The Palace software was created by Jim Bumgardner and produced by Time Warner in 1994, with a website that launched in 1995.

12 The title of the CD-ROM, *donald.rodney:autoicon v1.0*, leaves the door open to future versioning.

13 Stuart Hall's 1988 text 'New Ethnicities' addresses the use of the term 'black' as referencing 'the common experience of racism and marginalisation in Britain, which came to provide the category of a new politics of resistance among groups and communities with, in fact, very different histories, traditions and ethnic identities'. S. Hall, *Critical Dialogues in Cultural Studies* (ed. Kuan-Hsing Chen and David Morley), London: Routledge, 1996, p.441. This conception of 'political blackness', with roots in the trade union and anti-racism movements, served as a vital ground for post-War solidarity amongst people of African, Caribbean and South Asian descent experiencing racial discrimination in the UK. In parallel, in 1980s Britain the capitalised 'Black' was used in the context of cultural organising and beyond to mark the unified political struggle of an African diaspora. Across Rodney's work and writings, he used both uppercase and lowercase, seemingly without any consistent intent to signify either usage

differently. In a number of works, he also used the words 'Blk' and 'Blak' in particular reference to a Pan-African political identity. In this book, I have retained the original use or non-use of capitalisation when citing a particular source, and elsewhere chosen to use the lowercase 'black' in reflection of the term's mutability in different social and historical contexts, and in awareness of blackness as, in La Marr Jurelle Bruce's words, 'ever-unfurling rather than rigidly fixed'. L.J. Bruce, *How To Go Mad Without Losing Your Mind: Madness and Black Radical Creativity*, Durham, NC: Duke University Press, 2021, p.6.

14 Rodney studied art from 1981-85 at Trent Polytechnic in Nottingham and then from 1985-87 at the Slade School of Fine Art in London. Participating in the open exhibition organised alongside the First National Black Art Convention in Wolverhampton in 1982, he became a member of a group of artists known as The Blk Art Group, which included Eddie Chambers, Claudette Johnson, Keith Piper, Marlene Smith and others. Between 1982 and 1983 the group held a number of exhibitions, with a changing line-up of artists, under the title 'The Pan-Afrikan Connection'. Clarifying the multiplicity of groupings and collective organising occurring amongst black artists in the early 1980s, and challenging the present tendency to conflate these under the banner of The Blk Art Group, Chambers has stated: 'One of the most irksome and tiresome consequences of the conflation of multiple iterations of the loose group (which at different times during its existence was variously known as Wolverhampton Young Black Artists, the Pan African/Afrikan Connection, Art for Uhuru and, in its final stages, The Blk Art Group) is the problem of omission. The Blk Art Group has become increasingly identified with only a very limited number of artists, primarily Piper, Rodney, Smith and Johnson. Conspicuous by their absence from pretty much all 1980s-related attention are the likes of [Janet] Vernon, Dominic Dawes, Ian Palmer, Andrew Hazel and Wenda Leslie, all of whom have as much right to be recalled and cited as anyone else.' E. Chambers, 'Black Artists and the Fetishization of the 1980s', in *World is Africa: Writings on Diaspora Art*, London: Bloomsbury, 2021, pp.13-36.

15 Michel Foucault, 'What is an Author?' (trans. Donald F. Bouchard and Sherry Simon), in *Language, Counter-Memory, Practice: Selected Essays and Interviews* (ed. Donald F. Bouchard), Ithaca, NY: Cornell University Press, 1977, p.121.

16 Emmanuel Cooper, 'Helen Robertson, Maurice Hobson, Helen Underwood, Donald Rodney', *20/20*, August 1990.

17 'Donald Rodney: Autoicon', Arts Council application, December 1997, in Donald Rodney Papers, TGA 200321, series 1, item 27, Tate Archive, Tate Britain, London.

18 Jeremy Bentham, 'Auto-Icon; or, Further Uses of the Dead to the Living. A Fragment. From the MSS of Jeremy Bentham', c.1842, accessible at https://nla.gov.au/nla.obj-2810913207/view?partId=nla.obj-2810932468#page/n0/mode/1up (last accessed 13 January 2022).

19 The number of Internet users worldwide is thought to have grown from around 360 million in 2000 to nearly 5 billion in 2021.

20 S. Wynter and K. McKittrick, 'Unparalleled Catastrophe for Our Species?', *op. cit.*, p.54.

21 S. Wynter, '1492: A New World View', in *Race, Discourse, and the Origin of the Americas: A New World View* (ed. Rex Nettleford and Vera Lawrence Hyatt), Washington DC: Smithsonian Institution Press, 1995, p.7.

22 S. Hall, 'Encoding and Decoding on the Television Discourse', paper delivered for the Council of Europe Colloquy on 'Training in the Critical Reading of Television Language', Birmingham: Centre for Contemporary Cultural Studies, University of Birmingham, 1973, p.4. Emphasis in the original.

23 Other video materials include an interview with The Blk Art Group on *Ebony*, broadcast on BBC2 in 1984, and interviews with Rodney on late-night culture shows on BBC2 and CNN from 1991-92.

24 Interview with The Blk Art Group on *Ebony*, BBC2, 1984.

25 The Turing Test, originally called the 'imitation game' by mathematician Alan Turing in 1950, has become a cultural signifier of the ultimate proof of artificial intelligence equivalent to that of human intelligence.

26 Video game 'modding', where users create alterations to the back-end programming of a computer game, has been actively encouraged by game manufacturers since the early 1990s.

27 The terms 'glitch art' and 'glitch aesthetics' define an approach that emphasises fragmentation and repetition, and distinguishes between 'pure glitches' and those created by artists. Rosa Menkman's 'Glitch Studies Manifesto' states: 'Use bends and breaks as a metaphor for difference. As an artist, I find catharsis in disintegration, ruptures and cracks. I manipulate, bend and break any medium towards the point where it becomes something new. This is what I call glitch art.' R. Menkman, 'Glitch Studies Manifesto', 2009, available at https://amodern.net/wp-content/uploads/2016/05/2010_Original_Rosa-Menkman-Glitch-Studies-Manifesto.pdf (last accessed 13 January 2022).

28 Lubaina Himid, 'Fragments: An Exploration of Everyday Black Creativity and Its Relationship to Political Change', *Feminist Arts News*, vol.2, no.8, Autumn 1998, p.9.

29 Legacy Russell, *Glitch Feminism: A Manifesto*, London: Verso, 2020, p.13.

30 *Ibid.*, p.69.

31 *Ibid.*, p.107.

32 E. Chambers, 'Biography', December 1999, in *donald.rodney:autoicon v1.0, op. cit.*

33 Transcript of meeting with Donald Rodney plc, email attachment from Geoff Cox to Gilane Tawadros, 30 October 1998, Iniva archive, EXH 2000, np.

34 K. McKittrick, '(Zong) Bad Made Measure', in *Dear Science and Other Stories*, Durham, NC: Duke University Press, 2021, p.145.

35 M. NourbeSe Philip, *Zong! As told to the author by Setaey Adamu Boateng*, Middletown, CT: Wesleyan University Press, 2008, p.191 and 196.

36 K. McKittrick, '(Zong) Bad Made Measure', *op. cit.*, p.148.

37 Jean Fisher, 'In Living Memory ... Archive and Testimony in the Films of the Black Audio Film Collective', in *The Ghosts of Songs: The Film Art of the Black Audio Film Collective* (ed. Kodwo Eshun and Anjalika Sagar), Liverpool: Liverpool University Press, 2007, p.30.

38 J. Bentham, 'Auto-Icon; or, Farther Uses of the Dead to the Living', *op. cit.* Emphasis in the original.

39 Virginia Nimarkoh, 'Books, etc.', talk delivered at Iniva, 10 November 2008, as part the exhibition 'Donald Rodney: In Retrospect'.

40 J. Derrida, 'Signature Event Context', in *Limited Inc.*, Evanston, IL: Northwestern University Press, 1988, p.20.

41 S. Hall, 'Ethnicity: Identity and Difference', *Radical America*, vol.23, no.4, July–August 1989, p.9.

42 M. Foucault, *Discipline and Punish: The Birth of the Prison* (1977; trans. Alan Sheridan), New York: Vintage Books, 1995, p.208. For Foucault, 'the domain of panopticism is ... that whole lower region, that region of irregular bodies, with their details, their multiple movements, their heterogeneous forces, their spatial relations'.

43 M. Foucault, 'Technologies of the Self', in *Technologies of the Self: A Seminar with Michel Foucault* (ed. Luther H. Martin, Huck Gutman and Patrick H. Hutton), London: Tavistock Publications, 1988, p.18.

44 See, for example, Rodney's *Blood In My Eye* (1986), *The House that Jack Built* (1987) and *Self-Portrait: Black Men Public Enemy* (1990).

45 Denise Ferreira da Silva, *Toward a Global Idea of Race*, Minneapolis: University of Minnesota Press, 2007, p.xxxix.

46 *Ibid.*, p.xxiii.

47 Carson Cole Arthur helpfully underscores how 'it is important from the offset that we not forget *analytics* is inextricable to *raciality*. Failure to consider *the analytics* that is *of raciality* would lead to mistaking the term as merely a discursive concept (e.g. another way of saying "racialised" or "racial thinking") instead of recognising it as a politico-juridical programme, a production and mode of (transcendental) consciousness.' C. Cole Arthur, 'Denise Ferreira da Silva: Analytics of Raciality', *Critical Legal Thinking*, 20 July 2020, available at https://criticallegalthinking.com/2020/07/12/denise-ferreira-da-silva-analytics-of-raciality/ (last accessed 13 January 2022).

48 Bentham was a vocal supporter of calls for an Anatomy Act (eventually passed just

months after his death in 1832) to enable surgeons, teachers of anatomy and medical students to dissect bodies donated to them, as well as those 'unclaimed' after death. The latter tended to be those of individuals who died in prisons, workhouses and hospitals without family able to meet the costs of their burial. In 1824, Southwood Smith published the essay 'The Use of the Dead to the Living' in *The Westminster Review*, a journal founded by Bentham in 1823 as a site for the furthering of 'Radical' thought and ideas. Southwood Smith advocated for the repeal of the Murder Act, the criminalisation of exhumation and the development of official infrastructure to convey unclaimed bodies from 'hospitals, infirmaries, work-houses, poor-houses, foundling-houses, houses of correction and prisons' to medical schools. In Southwood Smith's estimation, this plan would 'put an immediate and entire stop to all the evils of the present system. ... It would tranquilize the public mind. Their dead would rest undisturbed ... and all the horrors which the imagination connects with its violation would cease for ever.'

49 The National Archives, Public Record Office (PRO), PROB 11/1801/468, Will of Jeremy Bentham of Westminster Middlesex, 21 June 1832.

50 It is thought that interest in Britain in the practice of *mokomokai*, the preserved heads of Māori, began with James Cook's first voyage to Aotearoa in 1769, during which Cook's botanist Joseph Banks is said to have traded linen for the head of a fourteen-year-old boy. The collecting of *mokomokai* in Britain and America into the nineteenth century led to a significant trade in exchange for muskets. It is likely that Bentham's interest in *mokomokai* also stemmed from the visit of a Māori chief, Hongi Hika, to London in 1820. Bentham's 'Auto-Icon' text reads: 'I do not stop to consider what, on another occasion, might be well worth considering, how it has chanced that the barbarous New Zealanders have preceded the most cultivated nations in the Auto-Icon art.' See Horatio Gordon Robley, *Moko, or Maori Tattooing*, London: Chapman and Hall, 1896; and Conal McCarthy, *Exhibiting Maori: A History of Colonial Cultures of Display*, Oxford: Berg, 2007.

51 Talrich used busts by the sculptor David d'Angers produced during Bentham's 1825 visit to Paris as templates. Talrich was the official producer of waxwork anatomical models at the Paris Faculty of Medicine from 1824-51. The production of such models, called ceroplastics, was prominent in Europe as of the late seventeenth century. The practice seeped into more popular arenas: notoriously, the Swiss physician Philippe Curtius, alongside his protégé Marie Grosholtz (later Marie Tussaud), established a 'wax salon' in Paris in 1765 that included two sections, one dedicated to fashionable Parisians including 'Marie Antoinette and her family eating dinner', the other to a 'chamber of horrors' staging the torture of infamous criminals. As the French Revolution took hold in Paris in 1789, Curtius and Grosholtz produced wax replicas of the severed heads of aristocratic enemies of the people, with the salon offering visitors a regularly updated record of the guillotined.

52 J. Bentham, 'Auto-Icon; or, Farther Uses of the Dead to the Living', *op. cit.*

53 *Ibid.* Emphasis in the original.

54 *Ibid.* The full list reads: '1. Moral, including 2. Political; 3. Honorific; 4. Dehonorific; 5. Economical, or money saving; 6. Lucrative, or money-getting; 7. Commemorational, including 8. Genealogical; 9. Architectural; 10. Theatrical; and 11. Phrenological.'

55 *Ibid.* Bentham cites Lord Mansfield, the arch-exponent of an author's right of property as common law. As Lord Chief Justice in the latter half of the eighteenth century, Mansfield is considered the founder of English commercial law. He is also notable for his verdicts in two cases related to the slave trade: *Somerset v Stewart*, which was held up by abolitionists as a step towards the outlawing of slavery in England; and *Gregson v Gilbert*, related to the insurance claim from the Zong massacre, in which Mansfield found that the enslaved were to be considered property that could be 'destroyed' in situations of absolute necessity.

56 See Eric Williams, *Capitalism & Slavery*, Chapel Hill: University of North Carolina Press, 1944.

57 J. Bentham, *Theory of Legislation* (1802; trans. from R. Hildreth), London: Trübner, 1864, p.207.

58 Thomas Carlyle, 'Occasional Discourse on the Negro Question', *Fraser's Magazine for Town and Country*, vol.40, December 1849, pp.670-79.

59 John Stuart Mill, 'The Negro Question', *Fraser's Magazine for Town and Country*, vol.41, 1850, pp.25-31.

60 It is notable that Mill, while embarking on a public career as the most prominent voice of classical liberalism, to a degree shaped British imperialist policy on India under indirect rule. In this role, Mill came to advocate for and support direct intervention in particular states and a programme of 'modernization', a perspective fully realised in the establishment of British direct rule in 1858, following the Indian Rebellion of 1857, the siege of Delhi and resulting massacre perpetrated by the East India Company.

61 Karl Marx, *Capital: A Critique of Political Economy, Volume I* (trans. Ben Fowkes), London: Penguin, 1976, p.280.

62 *Ibid.*

63 For a more thorough analysis of Marcel Broodthaers's *Figures of Wax*, see Shana G. Lindsay, '*Mortui Docent Vivos*: Jeremy Bentham and Marcel Broodthaers in *Figures of Wax*', *Oxford Art Journal*, vol.36, no.1, 2013, pp.93-107.

64 Mary Shelley, *Frankenstein; Or, The Modern Prometheus*, New York: Simon & Schuster, 2004, p.51.

65 Bentham adds a note to his 'Auto-Icon' text detailing a 'utilitarian' example of an automaton: 'The skeleton of Corder, the murderer, has been placed in a recess of the museum of the Suffolk Infirmary, Bury St Edmund's. It is covered with a glass case, beneath which is a box to receive contributions. ... By an ingeniously constructed spring, the arm of the skeleton points towards the box as soon as the visitors approach it. The receipts are said to reach £50 per annum.' Fairground automata such as fortune tellers and 'the laughing police-man' were popular in Britain from the Victorian era through to the mid-twentieth century. In relation to Rodney's *Pygmalion*, a notable example is 'Jolson Sings', an accompanied automated ventriloquist's dummy of the popular purveyor of minstrelsy Al Jolson.

66 James Baldwin, 'Freaks and the American Ideal of Manhood', *Playboy*, vol.32, no.1, January 1985, p.150.

67 Jean-Jacques Rousseau, *Pygmalion, Scene Lyrique* (1762), available at http://www.rousseauonline.ch/Text/pygmalion-scene-lyrique.php (last accessed 13 January 2022).

68 Saidiya V. Hartman, *Scenes of Subjection: Terror, Slavery, and Self-Making in Nineteenth-Century America*, New York: Oxford University Press, 1997, pp.31-32.

69 *Ibid.*, pp.56-58. See also José Esteban Muñoz, *Disidentifications: Queers of Color and the Performance of Politics*, Minneapolis: University of Minnesota Press, 1999, p.189.

70 Paul Gilroy, *The Black Atlantic: Modernity and Double Consciousness*, London: Verso, 1993, p.101.

71 D. Rodney, *Sketchbook No.44*, 1996. In London, the Special Collections library at Tate Britain holds 48 of Rodney's sketchbooks. They are also viewable online at https://www.tate.org.uk/art/archive/tga-200321/forty-eight-notebooks-and-sketchbooks-written-and-created-by-donald-rodney-and-the (last accessed 13 January 2022).

72 D.F. da Silva, *Toward a Global Idea of Race, op. cit.*, p. xiii.

73 M. Shelley, *Frankenstein, op. cit.*, p.52. The late-eighteenth-century experiments of physicians Erasmus Darwin and Luigi Galvani are mentioned, each of whom speculated on spontaneous vitality observed either within nature, or, in the case of Galvani, as a reaction to the passing of an electrical current through animal muscle.

74 C. Darwin, *The Descent of Man, and Selection in Relation to Sex*, London: J. Murray, 1871, p.172.

75 Da Silva analyses how the retention of globality, the 'ontological context the racial signifies', has resulted in the transformation of 'racial difference into a signifier of cultural difference' that continues to constitute a 'prolific strategy of power'. D.F. da Silva, *Toward a Global Idea of Race, op. cit.*, p.151 and xxxvi.

76 D. Rodney, *Sketchbook No.8*, 1985, see n.71 in this volume.

77 The first edition of *Encyclopædia Britannica*, published in 1768, was compiled by William Smellie and initiated in response to the French *Encyclopédie* edited by Denis Diderot and Jean le Rond d'Alembert, the principal catalogue of Enlightenment thought, first published in 1751. The *Encyclopedia Britannica* reappears in Rodney's work *My Catechism*, in

1997, in the form of plaster casts of the 20 volumes of the *Children's Britannica.*

78 William C. Boyd and Isaac Asimov, *Races and People,* New York: Abelard-Schuman, 1955.

79 K. McKittrick, '(Zong) Bad Made Measure', *op. cit.,* p.135.

80 See https://i-dat.org/donald-rodney-autoicon/ (last accessed 13 January 2022).

81 Larry McCaffery, 'An Interview with William Gibson', Mississippi Review, Vol.16, no.2/3, 1988, p.218.

82 See https://i-dat.org/donald-rodney-autoicon/ (last accessed 13 January 2022).

83 The Bentham Project, based at University College London, has undertaken to produce a new critical edition of the *Collected Works of Jeremy Bentham* through close research into all his extant papers, letters and writings. Since 1968, UCL has produced 34 volumes and it is envisaged that when completed the *Collected Works* will comprise 80 volumes.

84 See S. Wynter, 'No Humans Involved: An Open Letter to My Colleagues', *Forum N.H.I.: Knowledge for the 21st Century,* vol.1, no.1, Fall 1994.

85 'One World in Relation: Edouard Glissant in Conversation with Manthia Diawara', *Nka Journal of Contemporary African Art,* vol.3, no.28, March 2011, p.5.

86 S.V. Hartman, *Scenes of Subjection, op. cit.,* p.32.

87 D. Rodney, notes for *The Boy Looked at Babylon, Sketchbook No.10,* 1985, see n.71 in this volume.

88 D. Rodney, *Sketchbook No.48,* 1997-98, see n.71 in this volume.

89 Fredric Jameson, *Postmodernism, or, The Cultural Logic of Late Capitalism,* Durham, NC: Duke University Press, 1990, p.6.

90 Lisa Lowe, *Immigrant Acts: On Asian American Cultural Politics,* Durham, NC: Duke University Press, 1996, pp.2-3.

91 E. Chambers, 'The Art of Donald Rodney', in *Donald Rodney: Doublethink* (ed. Richard Hylton), London: Autograph, 2003, p.21.

92 P. Gilroy, *The Black Atlantic, op. cit.,* p.198.

93 K. Mercer, 'Diaspora Culture and the Dialogic Imagination: The Aesthetics of Black Independent Film in Britain', in *Welcome to the Jungle: New Positions in Black Cultural Studies,* London: Routledge, 1994, p.61.

94 Toni Morrison, 'The Site of Memory', in *Out There: Marginalization and Contemporary Cultures* (ed. Russell Ferguson, Martha Gever, Trinh T. Minh-ha and Cornel West), Cambridge, MA: MIT Press, 1990, p.304.

95 The exhibition was principally produced while Rodney was on an artist's placement at The Hub, a black community centre in Sheffield.

96 Press release for 'Donald Rodney: Crisis', Graves Art Gallery, 1989, accessible at http://new.diaspora-artists.net/display_item.php?id=63&table=artefacts (last accessed 13 January 2022). A number of works that featured in 'Crisis' include stencilled titles either within the main image or as separate captions, still using X-ray plates as the inscribed surfaces. This use of long descriptive titles bears similarities with the work of Terry Atkinson, whom Rodney admired. Atkinson's critical approach in the 1970s and 1980s to the history of history painting built on his earlier work as a member of Art & Language.

97 See Grace Redhead, '"A British Problem Affecting British People": Sickle Cell Anaemia, Medical Activism and Race in the National Health Service, 1975-1993', *Twentieth Century British History,* vol.32, no.2, 2021, pp.189-211.

98 In the Graves Gallery press release, Rodney wrote of his intent to 'establish a visual discourse that would produce meaning without mimicking Western Art tradition – "Our Master's Voice"'.

99 On Rodney's solo exhibition 'Critical' at Rochdale Art Gallery in 1990, the artist and curator Maud Sulter wrote: 'The potency of the x-ray as a metaphor evokes death, fragility, exposure, insight. So the layering of image and x-ray, the complementary use of oil pastel as a part of the surface, all evoke the body. A body politic. A site of struggle. The location of the transformation of power to action. A postmodern postmortem.' M. Sulter, *Critical* (exh. cat.), Rochdale: Rochdale Art Gallery, 1990, p.10.

100 Press release for 'Donald Rodney: Crisis', Chisenhale Gallery, London, 1989, available at http://new.diaspora-artists.net/display_item.php?id=137&table=artefacts (last accessed 13

January 2022). The Chisenhale Gallery press release does not seem to have been written by Rodney. The press release he authored for Graves Gallery addresses more pointedly racism as a societal disease.

101 Ambalavaner Sivanandan, 'Race, class and the state: the black experience in Britain', *Race and Class*, vol.17, no.4, 1976, p.348.

102 D. Rodney, *Sketchbook No.23*, 1988, see n.71 in this volume.

103 Winston Rose was 27 when, following violent police restraint, he died in a police van on the way to hospital in London in 1981; Clinton McCurbin was 23 when he died of asphyxia following a similar assault by police in Wolverhampton in 1987.

104 F. Jameson, *Postmodernism, op. cit.*, p.18.

105 S. Hall, 'Minimal Selves', in *The Real Me: Postmodernism and the Question of Identity* (ed. Lisa Appignanesi), ICA Documents 6, London: Institute of Contemporary Arts, 1987, p.44.

106 S. Hall, 'Cultural Identity and Diaspora', in *Undoing Place: A Geographical Reader*, London: Routledge, 1997, p.235.

107 P. Gilroy, 'Cruciality and the frog's perspective: An agenda of difficulties for the black arts movement in Britain', *Third Text*, vol.2, no.5, 1988, p.40. Emphasis in the original.

108 *Ibid.*, p.37. Gilroy borrows the term 'populist modernism' from Werner Sollor's study *Amiri Baraka/Leroi Jones, The Quest for a Populist Modernism*, New York: Columbia University Press, 1978.

109 *Ibid.*, p.39.

110 Gilroy criticises the rarefied non-vernacular forms of 'black visual arts and film' as being dependent on white-dominated 'overground cultural institutions'. Addressing the circulation of Black Audio Film Collective's film *Handsworth Songs* (1986), he states: '[T]here is no base or context for the type of films they [BAFC] want to make within the black communities in this country.' This concern is foreshadowed in Rodney's 1985 undergraduate thesis; addressing the work of BAFC, Ceddo and Sankofa, Rodney saw distinct differences in the strategies and approaches adopted. Despite lauding BAFC as being 'at the forefront of the cultural revolution being waged by black filmmakers for the minds of black people', he also concluded that they 'seem to have immersed themselves in an intellectual void'. In contrast, Rodney held up Menelik Shabazz and Ceddo's 1981 film *Burning an Illusion*, and its basis in human drama and the relatable portrayal of its characters to a black audience, as an exemplary success. Nevertheless, at the level of form and political aesthetics, Rodney's interest in film, moving image and montage remained strong, along with his friendships with John Akomfrah, Eddie George and Trevor Mathison of BAFC. His sketchbook notes indicate ideas for slide-tape works – possibly influenced by BAFC's early *Expeditions* duology made in 1983 and 1984 – such as *The Boy Looked at Babylon* (c. 1985). The use of stencilled text in Rodney's work prior to 'Crisis', often over a series of panels joined together as in a filmic storyboard, further indicates a shared formal language with *Expeditions* (both *Expeditions One*, subtitled *Signs of Empire*, and part two, *Images of Nationality*, made use of a performative choreography of 35mm image and text slides and overlaid sound), as well as the influence of Keith Piper's work on both Rodney and BAFC. See D. Rodney, 'Black Independent Film as part of the Black Art Movement', unpublished undergraduate thesis, Trent Polytechnic, Nottingham, March 1985, Donald Rodney Papers, TGA 200321, series 2, item 1, Tate Archive, Tate Britain, London.

111 L. Himid, 'Fragments', *op. cit.*, p.9.

112 Himid refers to quilts made by enslaved women in America and those of the Zamani Soweto Sisters Council during apartheid rule in South Africa as exemplifying a basis in black creativity and resistance.

113 Plato understood writing as a device of artificial, externalised memory, with the objects containing such writing – notebooks, public records etc. – as hypomnemata. Michel Foucault saw the aim of this activity as 'to make one's recollection of the fragmentary *logos*, transmitted through teaching, listening, or reading, a means of establishing a relationship of oneself with oneself, a relationship as adequate and accomplished as possible'. M. Foucault, 'Self Writing: Hupomnemata', *Corps écrit*, no.5, February 1983, translation available at https://foucault.info/documents/foucault.hypomnemata.en/ (last accessed 13 January 2022). Building on the work of Foucault and Jacques Derrida, philosopher Bernard

Stiegler called hypomnemata 'dead memory', yet contested the Platonic opposition between 'psychical living memory and technical dead memory', instead seeking to 'rethink memory as a process of grammatisation, where living and dead compose without end'. B. Stiegler, 'Anamnesis and Hypomnesis', 2010, available at https://arsindustrialis.org/anamnesis-and-hypomnesis (last accessed 13 January 2022).

114 *Ibid.*

115 Adeola Solanke, 'Donald Rodney', *Art Monthly*, issue 124, 1 March 1989, p.13.

116 B. Stiegler, 'Anamnesis and Hypomnesis', *op. cit.*

117 D. Rodney, *Sketchbook No.26*, 1989, see n.71 in this volume. Himid's discomfort echoes Salman Rushdie's notorious critical responses to the release of BAFC's *Handsworth Songs* (1986): 'What we get is what we know from TV. Blacks as trouble; blacks as victims.' S. Rushdie, '"Songs" Doesn't Know the Score', *The Guardian*, January 1987.

118 D. Rodney, *Sketchbook No.26*, 1989, see n.71 in this volume.

119 Fred Moten, 'The Touring Machine (Flesh Thought Inside Out)', in *Plastic Materialities: Politics, Legality, and Metamorphosis in the Work of Catherine Malabou* (ed. Brenna Bhandar and Jonathan Goldberg-Hiller), Durham, NC: Duke University Press, 2015, p.276.

120 A paragraph in the exhibition publication considers the film's representation of 'codes of friendship, duty and trust' as the basis of a search for a better world. In both the film and poem, however, the image of a noble man seeking the mythical land of El Dorado can also be read as summoning the spirit of 'manifest destiny' and the associated forces of colonial capitalism. See Edgar Allan Poe, 'Eldorado', in *The Flag Of Our Union*, 21 April 1849. El Dorado, originally El Hombre Dorado ('The Golden Man') or El Rey Dorado ('The Golden King'), was the name that sixteenth-century Spanish invaders gave to the Muisca people's mythical chief who, for an initiation rite, was said to have covered himself with gold dust before submerging himself in Lake Guatavita. The myth metamorphosed over time into the name for a lost city or empire of gold, and became a construct of the settler-colonial erasure of indigenous peoples in South America. The related lust for gold served for Poe as an allegorical hermeneutic of the Californian gold rush of the mid-nineteenth century.

121 S. Wynter, *Black Metamorphosis: New Natives in a New World*, unpublished manuscript, n.d., p.83.

122 *Ibid.*, p.60.

123 See Orlando Patterson, *The Sociology of Slavery: An Analysis of the Origins, Development, and Structure of Negro Slave Society in Jamaica*, London: Associated University Press, 1969; and *The Children of Sisyphus*, Kingston: Bolivar Press, 1968; *Die the Long Day*, New York: William Morrow & Company, 1972.

124 Ruth Kelly, 'Interview with Donald Rodney, London, 11 March 1994', *Donald Rodney: Autoicon.*

125 S. Hall, 'Cultural Identity and Diaspora', *op. cit.*, p.226.

126 If the use of glass vitrines is a knowing reference to the tank structures that became a trademark of Damien Hirst's work and a totem of the media-appointed 'Young British Artists' in the early 1990s, *Land of Milk and Honey I* and *II* foreground open decay and entropy rather than the embalmed and controlled environments that Hirst produced.

127 Donald Rodney Papers, TGA 200321, series 5, box 2, item 36, Tate Archive, Tate Britain, London.

128 See Robert Farris Thompson, *Flash of the Spirit: African and Afro-American Art and Philosophy*, New York: Random House, 1984, pp.132-45.

129 In her text 'Illness as Metaphor: Donald Rodney's X-ray Photographs', Jareh Das insightfully associates *Land of Milk and Honey I* and *II* with the formal qualities of a *Wunderkammer*, the densely packed cabinet of curiosities that emerged in Europe in the sixteenth century as a means to present and categorise wonders and curiosities of the natural world. Das positions them as predecessors of later freak shows, which 'contributed to a spectacularization of nonnormative bodies, including black and disabled bodies as "other/abnormal", in order to establish notions that have informed healthy, heteronormative, and "normal" bodies.' J. Das, 'Illness as Metaphor: Donald Rodney's X-ray Photographs', *Nka: Journal of Contemporary African Art*, no.45, November 2019, p.92.

130 D. Rodney, *Sketchbook No.44*, 1996, see n.71 in this volume.

131 The term 'metaverse', a 'computer-generated universe', was coined by Neal Stephenson in his sci-fi novel *Snow Crash*, New York: Bantam Books, 1992.

132 Roy Ascott, 'Seeing Double: Art and the Technology of Transcendence', in *Reframing Consciousness: Art, Mind and Technology* (ed. R. Ascott), Exeter: Intellect, 1999, p.68. Ascott seemingly ignores W.E.B. Du Bois's use of 'double consciousness' as a term depicting a self-consciousness engendered through racialised othering.

133 See David A. Bailey and S. Hall, ed., 'Critical Decade: Black British Photography in the 1980s', *Ten.8*, vol.2, no.3, 1992. With contributions from artists and writers including Sonia Boyce, Rotimi Fani-Kayode, Joy Gregory, Sunil Gupta, Isaac Julien, Kobena Mercer, Pratibha Parmar, Ingrid Pollard, Lorna Simpson, Gilane Tawadros and Carrie Mae Weems.

134 Iniva was initially instigated by the UK Arts Council and was contentious in seemingly sidestepping the issue of structural racism of existing arts institutions by establishing a stand-alone organisation that would give 'priority to artists who have been marginalised on the basis of race, gender and cultural differences'. See E. Chambers, 'Iniva: Everything Crash', *Afterall*, issue 39, July 2018, pp.50-59.

135 'Global Proposals: Nikos Papastergiadis talks to Gilane Tawadros', *frieze*, November-December 1994, p.29.

136 A key project produced by Digital Diaspora was *Digital Slam* (1995), held at the Institute of Contemporary Arts, London. Predominantly organised by Derek Richards, the event used telecommunications networks to facilitate a real-time transatlantic jam session between musicians in New York and London.

137 Janice Cheddie, 'Beyond the Digital Diaspora', in *Seventh International Symposium on Electronic Art: Proceedings* (ed. Michael B. Roetto), Rotterdam: ISEA Foundation, 1996, p.146.

138 Roshini Kempadoo, 'Beyond the Digital Diaspora: Anxious Repetition', in *ibid.*, p.146.

139 'Keith Piper: Relocating the Remains', Iniva, London, July 1997-February 2000.

140 G. Tawadros, 'Telling Tales: Keith Piper's "Relocating the Remains"', *Keith Piper: Relocating the Remains* (exh. cat.), London: Iniva, 1997.

141 K. Piper, *Code/Software, Signifyin' & CyberEbonics* (2015), first shown as part of 'Ghosts: Keith Piper and Gary Stewart in Conversation', Camberwell College of Arts, London, January 2015, available at http://www.keithpiper.info/codeinprog.html (last accessed 13 January 2022).

142 K. Piper, 'Code_II: CyberEbonics and a return to Code_v1.0', available at http://www.keithpiper.info/code_2.html (last accessed 13 January 2022).

143 For a more substantive analysis of 'Relocating the Remains', see Ashley Dawson, 'Surveillance Sites: Digital Media and the Dual Society in Keith Piper's "Relocating the Remains"', *Postmodern Culture*, vol.12, no.1, September 2001, available at http://pmc.iath.virginia.edu/issue.901/12.1dawson.html (last accessed 13 January 2022).

144 S. Wynter, *Black Metamorphosis*, *op. cit.*, p.116.

145 Lev Manovich, *The Language of New Media*, Cambridge, MA: MIT Press, 2001, pp.221-27.

146 N. Katherine Hayles, *How We Think: Digital Media and Contemporary Technogenesis*, Chicago: University of Chicago Press, 2012, p.183. Emphasis in the original.

147 L. Manovich, *The Language of New Media*, *op. cit.*, p.227.

148 Mieke Bal, *Narratology: Introduction to the Theory of Narrative*, Toronto: University of Toronto Press, 1998, p.6.

149 Transcript of meeting with Donald Rodney plc, *op. cit.*, np.

150 M. Bal, *Narratology*, *op. cit.*, p.145.

151 Graham Harwood, *Rehearsal of Memory*, London: Artec and Book Works, 1996.

152 Contributors to *Brandon* include Pat Cadigan, Lawrence Chua, Auriea Harvey, Jordy Jones, Francesca da Rimini, Allucquére Rosanne 'Sandy' Stone, Beth Stryker and Susan Stryker. The work's events include 'A Virtual Court Test Trial for Brandon' at the Institute for Arts and Civic Dialogue, Harvard University, Cambridge, MA; 'Digi Gender, Social Body: Under the Knife, Under the Spell of Anesthesia', staged inside the Theatrum Anatomicum at De Waag, Amsterdam and at the SoHo branch of the Guggenheim Museum in New York; and

'Would the Jurors Please Stand Up? Crime and Punishment as Net Spectacle', simultaneously staged at the Theatrum Anatomicum and the Guggenheim SoHo.

153 Frantz Fanon, *Black Skin, White Masks* (trans. Richard Philcox), New York: Grove Press, 2008, p.90.

154 F. Moten, 'The Touring Machine (Flesh Thought Inside Out)', *op. cit.*, p.276.

155 D. Rodney, notes titled 'Self-Portrait', *Sketchbook No.30*, 1989, see n.71 in this volume. The words here are circled in the original.

156 Donna J. Haraway, 'A Cyborg Manifesto: Science, Technology and Socialist Feminism in the Late Twentieth Century', in *Manifestly Haraway*, Minneapolis: University of Minnesota Press, 2016, p.69. For Haraway, Michel Foucault named a form of power at the moment of its implosion in the 1970s: 'Our dominations don't work by medicalization and normalization anymore; they work by networking, communications redesign, stress management ... the discourse of biopolitics gives way to technobabble.'

157 N.K. Hayles, *How We Became Posthuman*, *op. cit.*, p.34.

158 D.J. Haraway, 'A Cyborg Manifesto: Science, Technology and Socialist Feminism in the Late Twentieth Century', *op. cit.*, p.69. In reference to Michel Foucault's *The Birth of the Clinic* (1963), Haraway notes: 'It is time to write The Death of the Clinic. The clinic's methods required bodies and works; we have texts and surfaces.'

159 Therí Alyce Pickens, *Black Madness: Mad Blackness*, Durham, NC: Duke University Press, 2019, p.20.

160 D.J. Haraway, 'A Manifesto for Cyborgs: Science, Technology and Socialist Feminism in the 1980s', *Socialist Review*, March/April 1985, p.97.

161 Alison Kafer, *Feminist Queer Crip*, Bloomington: University of Indiana Press, 2013, p.111-25. Emphasis on first quote in the original. See also Robert McRuer, *Crip Theory: Cultural Signs of Queerness and Disability*, New York: New York University Press, 2006.

162 Mike Phillips, 'Memoria Technica, Donald G Rodney: Autoicon', *Mediaspace 5*, May 1998, n.p.

163 *Ibid.*

164 R. Kelly, 'Interview with Donald Rodney, London, 11 March 1994', *op. cit.*

165 Elaine Scarry, *The Body in Pain: The Making and Unmaking of the World*, Oxford: Oxford University Press, 1985, p.162.

166 T.A. Pickens, 'Pinning Down the Phantasmagorical: Discourse of Pain and the Rupture of Posthumanism in Evelyne Accad's "The Wounded Breast" and Audre Lorde's "The Cancer Journals"', in *Blackness and Disability* (ed. Christopher M. Bell), East Lansing: Michigan State University Press, 2011, p.91.

167 E. Chambers, 'His Catechism: The Art of Donald Rodney', *Third Text*, vol.12, no.44, 1998, p.49. The exhibition was 'Let the Canvas Come to Life with Dark Faces' at Castle Museum in Nottingham in 1990.

168 In an artist statement from the time, Rodney quoted the pioneer of black nationalism Marcus Garvey as saying: 'A people with no history is like a tree with no roots.' D. Rodney, 'e=mc2', in *Critical*, *op. cit.*, p.2.

169 See *Brown Coloured Black* (1983), *A Beginners Guide to Blak History* (1987) and *Dejavoodoo* (1987).

170 D. Rodney, *Sketchbook No.28*, 1989, see n.71 in this volume.

171 See V. Nimarkoh, 'Image of Pain: Physicality in the Work of Donald Rodney', *op. cit.*; David Thorp, 'Flesh of My Flesh', *Body Visual*, London: The Arts Catalyst, 1996, pp.29-30; and interview with D. Rodney in Eddie George and Trevor Mathison's video *Three Songs on Pain, Time and Light* (1996).

172 Rodney was involved with other similar projects in the 1990s, where artistic practices were placed in critical relation to the institutional structures and technologies of the health system, including 'Breaths: Art, Health and Empowerment' (1991) at Rochdale Art Gallery, and 'Care and Control' (1995) at Hackney Hospital in East London.

173 Nicola Triscott, introduction to *Body Visual*, *op. cit.*, p.5.

174 The Human Genome Project now estimates that humans carry around 20,000 to 25,000 genes, not the 100,000 projected in the mid-1990s. Of the 25,000 genes, 99 per cent are identical in all humans.

175 Alison Bybee, 'In a Strange Terrain: Science on a Molecular Level', in *Body Visual, op. cit.*, p.51.

176 In 2021, a UK parliamentary report on sickle cell found that 'patients are regularly treated with disrespect, not believed or listened to' and that '[c]are failings have led to patient deaths over decades and "near misses" are not uncommon'. Sickle Cell Society and Aidan Rylatt, *No One's Listening: An Inquiry Into the Avoidable Deaths and Failures of Care for Sickle Cell Patients in Secondary Care*, All-Party Parliamentary Group on Sickle Cell and Thalassaemia, November 2021, p.6, available at https://www.sicklecellsociety.org/wp-content/uploads/2021/11/No-Ones-Listening-PDF-Final.pdf (last accessed 13 January 2022).

177 Elizabeth Nneka Anionwu, 'Health Education and Community Development for Sickle Cell Disorders in Brent', PhD dissertation, University of London Institute of Education, 1988, pp.235-37. Also see Grace Redhead, '"A British Problem Affecting British People"', *op. cit.*

178 Susan Sontag, *Illness as Metaphor & AIDS and its Metaphors*, London: Penguin Books, 1991.

179 D. Rodney, *Critical, op. cit.*, p.8

180 A 'hostile environment' policy was initiated in 2012 by the UK Home Office under the Conservative-Liberal Democrat coalition. It took the form of a set of administrative and legislative measures designed to make staying in the UK as difficult as possible for people without leave to remain, in order to pressure them to 'voluntarily leave'. In November 2017, media reports began to address how the policy had led to Commonwealth immigrants who arrived in the UK before 1973 being threatened with deportation if they could not prove their right to remain, despite the fact that there were no such documents required by the state when the individuals first arrived. At least 83 people were wrongly deported, many of whom were part of the Windrush generation. In recent times, the imbrication between health, race and social welfare has been nowhere more apparent than in the massive disparities in the effects of the COVID-19 pandemic between people of colour and white people in the UK and elsewhere.

181 P. Gilroy, *Against Race: Imagining Political Culture Beyond the Color Line*, Cambridge, MA: Harvard University Press, 2000, p.20.

182 D.F. da Silva, *Toward a Global Idea of Race, op. cit.*, pp.8-9.

183 Hortense J. Spillers, 'Mama's Baby, Papa's Maybe: An American Grammar Book', *Diacritics*, vol.17, no.2, Summer 1987, p.67. Emphasis in the original.

184 See 'Of Human Flesh: An Interview with R.A. Judy by Fred Moten', *b2o*, May 2020, available at https://www.boundary2.org/2020/05/of-human-flesh-an-interview-with-r-a-judy-by-fred-moten/ (last accessed 13 January 2022).

185 H.J. Spillers, 'Mama's Baby, Papa's Maybe', *op. cit.*, p.68.

186 S.V. Hartman, *Scenes of Subjection, op. cit.*, pp.57-59.

187 Stephen Weller insightfully speculates on how entering *Autoicon* through its original online landing page 'would've been organized around the virtual act of touching a piece of Donald Rodney, of feeling his skin, an intimate reiteration of the works fragile origins and an affirmation of its status as a form of digital embodiment'. S. Weller, 'Autoicon - The Digital Body', 2021, unpublished.

188 See N.K. Hayles, *How We Became Posthuman, op. cit.*, pp.198-207.

189 Diane Symons, '"In the House of My Father": Fragments of Body and Time', *Paper*, no.1, October 2012, n.p.

190 Linda Nochlin, *The Body in Pieces: The Fragment as a Metaphor of Modernity*, London: Thames & Hudson, 1994, p.7 and 53. Nochlin points to Théodore Géricault's 1818-19 paintings of severed limbs and heads as echoing the terror of the French Revolution and combinations of scientific objectivity and romantic melodrama. These images resonate with Jeremy Bentham's contemporaneous position of embracing anatomical dissection, while seeking a higher state of totality in his Auto-Icon.

191 Nirmala Erevelles, *Disability and Difference in Global Contexts: Enabling a Transformative Body Politic*, New York: Palgrave Macmillan, 2011, p.36.

192 E. Scarry, *The Body in Pain, op. cit.*, p.170.

193 The books include Octavia E. Butler's *Dawn* (1987), McKenzie Wark's *Molecular Red: Theory for the Anthropocene* (2015), Joanna Russ's *The Female Man* (1975), Alison Kafer's *Feminist, Queer, Crip* (2013), Georges Canguilhem's *The Normal and the Pathological* (1966),

Audre Lorde's *Sister Outsider* (1984) and Fred Moten and Stefano Harney's *The Undercommons: Fugitive Planning & Black Study* (2013).

194 Carolyn Lazard, 'How to be a Person in the Age of Autoimmunity', *Cluster Magazine*, 2013, available at https://static1.squarespace.com/static/55c40d69e4b0a45eb985d566/t/58cebc9dc534a59fbdbf98c2/1489943709737/HowtobeaPersonintheAgeofAutoimmunity+%281%29.pdf (last accessed 13 January 2022).

195 Mara Mills and Rebecca Sanchez, 'Giving it Away: Constantina Zavitsanos on Disability, Debt, Dependency', *Art Papers*, 2019, available at https://www.artpapers.org/giving-it-away/ (last accessed 13 January 2022).

196 *Psalms*, i-DAT, 1997 (updated 2016), available at https://i-dat.org/psalms/ (last accessed 13 January 2022).

197 Jane Bilton, exhibition brochure for '9 Night in Eldorado', South London Gallery, 1997.

198 Julia Watts Belser, 'Vital Wheels: Disability, Relationality, and the Queer Animacy of Vibrant Things', *Hypatia*, vol.31, no.1, Winter 2016, p.12.

199 Park McArthur, 'Sort of Like a Hug: Notes on Collectivity, Conviviality, and Care', *The Happy Hypocrite*, no.7, 'Heat Island' (ed. Mason Leaver-Yap), London: Book Works, 2014, p.56. In this passage, McArthur references scholar Jasbir K. Puar's notion of conviviality: 'As an attribute and function of assembling ... conviviality does not lead to a politics of the universal or inclusive common, nor an ethics of individuatedness, rather the futurity enabled through the open materiality of bodies as a Place to Meet.' Jasbir K. Puar, 'Prognosis time: Towards a geopolitics of affect, debility and capacity', *Women & Performance*, vol.19, issue 2, 2009, p.168. For an exploration of approaching 'care as an event', see also P. McArthur and Constantina Zavitsanos, 'Other forms of conviviality: The best and least of which is our daily care and the host of which is our collaborative work', *Women & Performance*, vol.23, issue 1, 2013, pp.126-32.

200 P. McArthur, 'Sort of Like a Hug', *op. cit.*, p.56.

201 P. McArthur, 'Kunsthalle_guests Gaeste.Netz.5456', 15 August-4 October 2020, available at https://kunsthalle-bern.ch/en/exhibitions/2020/park-mcarthur/ (last accessed 13 January 2022).

202 *Ibid.*

203 P. McArthur, 'Sort of Like a Hug', *op. cit.*, p.51.

204 D. Rodney, *Sketchbook No.46*, 1997, see n.71 in this volume. The role of spoken or sung psalms in Pentecostal liturgy is a contested one: over half of the texts in Psalms are forms of lament, written in moments when God is perceived to have forsaken the author; in contrast, Pentecostal services foreground praise and worship, and resist negativity.

205 Rodney's sketchbooks suggest an earlier title for the work as *Psalms Soliloquy*, an even more strident articulation of an unrealised or absent act of vocalised inner thought.

206 D. Rodney, *Sketchbook No.26*, 1989, see n.71 in this volume.

207 M. Sulter, 'Call and Response', *Feminist Art News*, vol.2, no.1, Autumn 1988, p.18. Besides her own artistic practice, Sulter's work as a curator was vital to the British art scene in the 1980s and early 1990s. Between 1985-93, she curated and co-curated around sixteen exhibitions at Rochdale Art Gallery, including, with Lubaina Himid, Donald Rodney's solo exhibition 'Critical' in 1990.

208 F. Moten, 'The Touring Machine (Flesh Thought Inside Out)', *op. cit.*, p.266.

209 Jasbir Puar writes of conviviality in similar terms, as an ethical orientation open to destablisation, 'an openness to something other than what we might have hoped for'. J. Puar, 'Prognosis time', *op. cit.*, p.169.